Uniquely Cork

Uniquely Cork

Photographs and Text
by
Niall Foley, L.R.P.S.

The Collins Press

Published by The Collins Press, Carey's Lane, Cork.

Text and photographs © Niall Foley 1991

Printed in Ireland by Colour Books Ltd., Dublin.
Duotone separations by Litho Studios Ltd., Dublin.
Typeset by Upper Case Ltd., Cork.

ISBN 0951603639

For Terry

*Without whose assistance and encouragement the
task would never have been completed.*

Preface

When I was asked to do this series of photographs my response was positive and immediate. However, once the initial euphoria had receded, I was left with the realisation that I had committed myself to doing something but was not exactly sure what. Over the years I had seen books on different cities by various photographers. All that I knew was that I wanted to do something different.

I approached the task by spending over a year wandering around the city photographing things and scenes that appealed to me. This has evolved into what are a series of photographic essays. I set out to capture a feeling for the city and its people. There is no attempt in this series of photographs to produce the definitive book on Cork. It is purely my reaction to scenes that presented themselves to me. With regard to the people who appear in the photographs no attempt was made to pose them. They were photographed in their natural environment, doing what they were doing when I chanced upon them.

The title of the book reflects my approach to the project. Each city and its people have aspects that are unique. I have concentrated on what, for me, makes this city and its people unique.

It would be remiss of me not to thank all the people who have assisted in various ways, ranging from suggesting locations to the more practical side of supplying pieces of equipment.

Niall Foley, L.R.P.S.,
June 1991

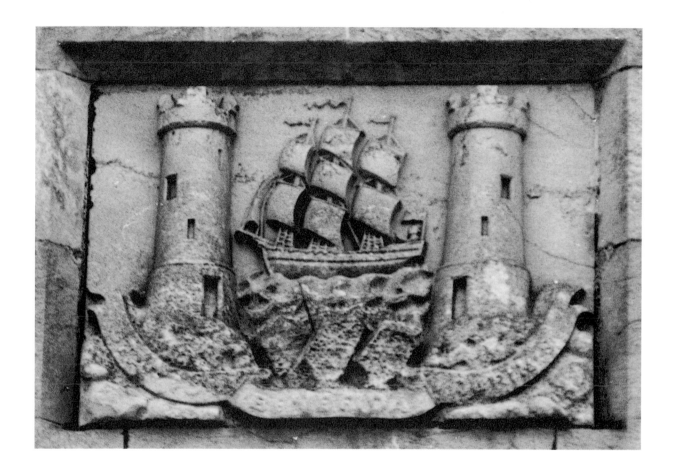

"Cork is the loveliest city in the world. Anybody who does not agree with me either was not born there or is prejudiced. The streets are wide, the quays are clean, the bridges are noble. Two wide channels of the river reflect glittering limestone buildings. It is above all, a friendly city, one that you will not easily forget".

Robert Gibbings

Poet and author.

Blackrock Castle

During the reign of James 1, Lord Mountjoy, the Viceroy of Ireland, built the first castle on "The Black Rocks" and there has been some type of castle or fortress on the site since then. The building was originally erected to protect shipping from pirates. It was also used as a type of lighthouse to guide shipping to the city. The light was not the modern type, rather it was a turf fire which was lit on top of the old building. Over the years the building has seen many uses, including that of an admiralty court. One of its main uses was that of a banqueting hall for civic functions. It was during one of these functions that the castle was destroyed by fire. It was rebuilt in 1829 for the sum of £1,000.00. The architects were the brothers Pain from London who also designed the nearby Church of Ireland. The castle is now used as a restaurant and licensed premises.

Facing page: The main gates of Blackrock Castle.

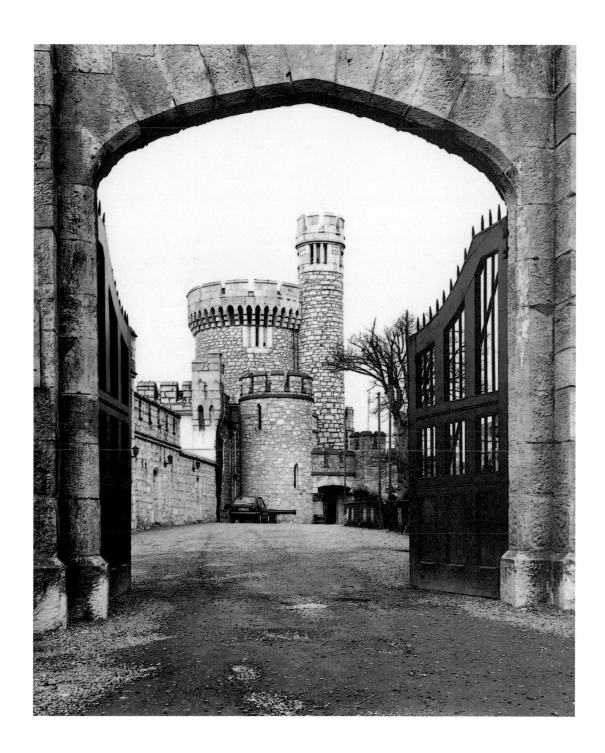

Blackrock

Before the city developed to its present size it was surrounded by a number of small villages. These have now been absorbed into the city and, in the main, it is difficult to recognise the original villages. To some extent Blackrock is the exception. Perhaps its location on the riverfront has helped it. The community was principally a fishing and market gardening one. When Queen Victoria visited Cork in August of 1849 her procession upriver was interrupted by the fishermen of Blackrock who presented her with a salmon.

Facing page: A successor of the salmon fishermen hauling in his boat.

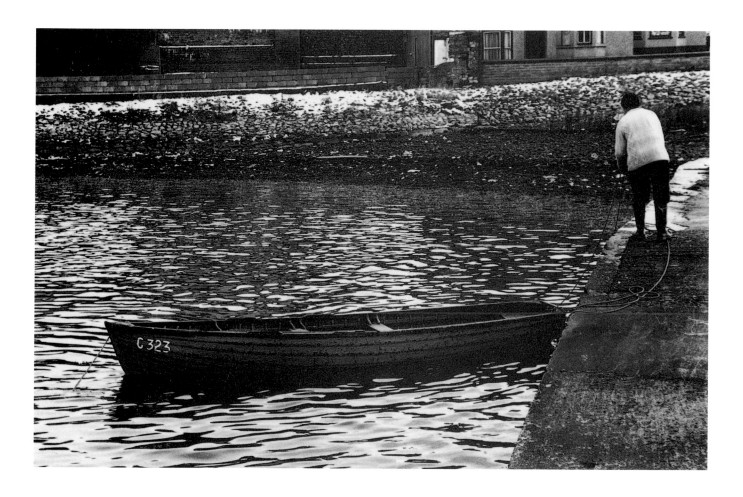

The Old and the New

If one of the old-time fishermen was to pay a visit to his old port a number of things would look familiar to him. He would recognise the upturned, wooden fishing boats on the bank but he would surely be nonplussed by the modern container terminal on the Tivoli side of the river. The very fact of there being land there would confuse him as all that was there in his time was mud flats.

Facing page: Wooden fishing boats and high-tech Tivoli docks.

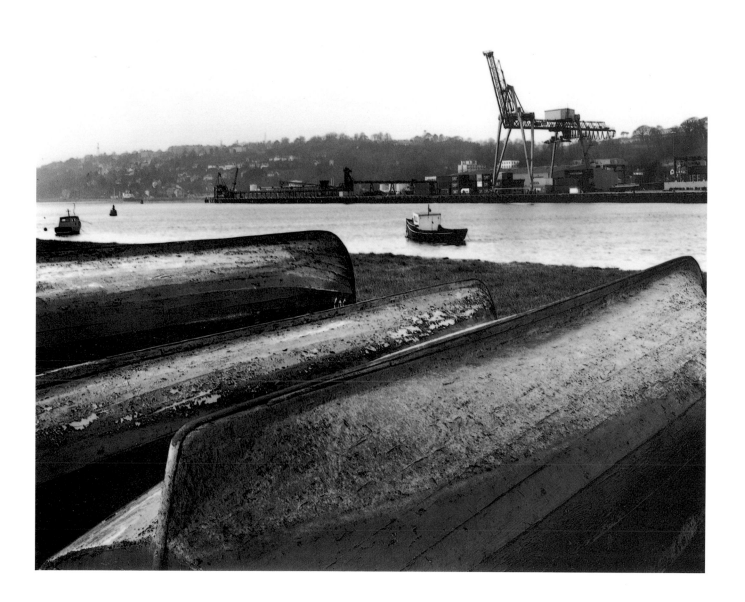

Rowing

Blackrock village and its environs are associated with watersports and there are three boat clubs along the Marina. The earliest recorded regatta was held in August of 1844, along what we now know as the Marina. Since then the annual regatta has been one of the sporting highlights of the year. It attracts crews from all over Ireland and abroad. During the training season one of the common sights is that of boats training in the river with the coach cycling along the bank shouting instructions.

Facing page: A coach and his pupil.

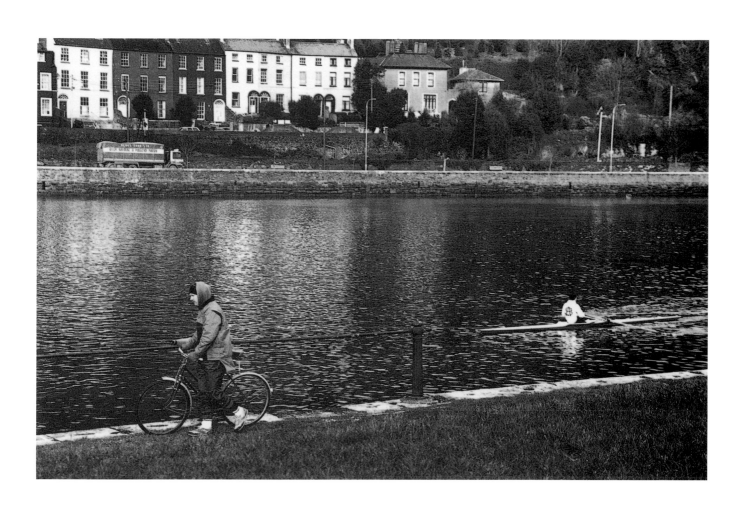

The Twenty-five to One Gun

The city end of the Marina, near Shandon Boat Club, is now a rather quiet area frequented mainly by members of the rowing fraternity. In the earlier part of this century it was a more lively spot. It boasted of a bandstand, a ceremonial mound topped with a 140-foot flagpole and a cannon gun which is now set in a concrete plinth. In various parts of the world it was not unusual for a gun to be discharged at midday so that the timepieces of the local inhabitants could be checked. Cork was however unique in that its gun was fired at twenty-five minutes to one. This arose out of an agreement made in 1876 between the London Postmaster General and the Cork Harbour Commissioners to allow Greenwich Mean Time to be proclaimed in Cork. This gun, which is a relic of the Crimean War, was set up in its present position and daily a signal was flashed by telegraph from Greenwich to Cork at one pm. As Cork is five degrees west of Greenwich the gun was fired at twenty-five minutes to one. The gun was last fired in the 1920's and it would be nice to see the gun and the area restored to its former glory.

Facing page: The Twenty-five to One Cannon.

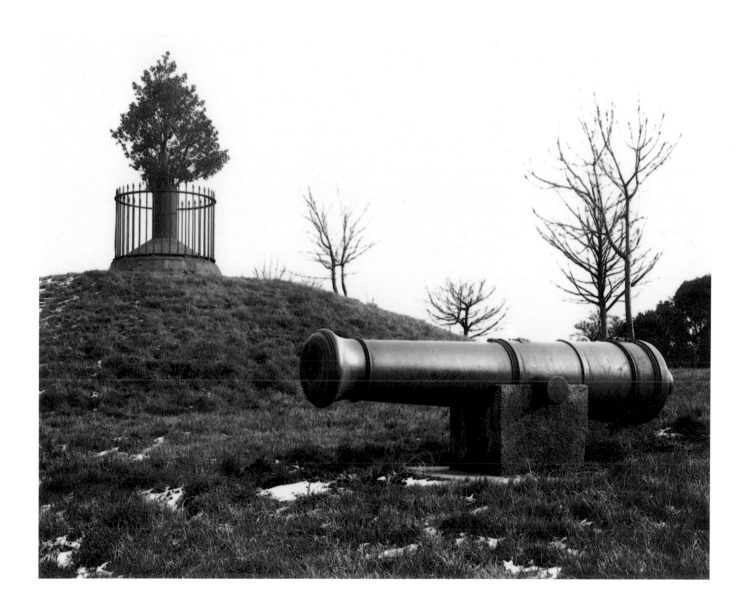

City Hall

This building replaced the old city hall which was burned down in 1920. It is the administrative centre for the city, which by virtue of its ancient charter, is one of the few cities in the country to have a Lord Mayor. He or she and the city councillors are elected by the people to decide on policy matters which are then implemented by the city officials. It is also one of the main cultural centres in the city and its spacious hall is used for events such as the International Choral Festival, symphony orchestra recitals, etc.. Attractively located by the river it can be appreciated from a number of vantage points since it is bounded on three sides by wide roads.

Facing page: City Hall viewed from the river side.

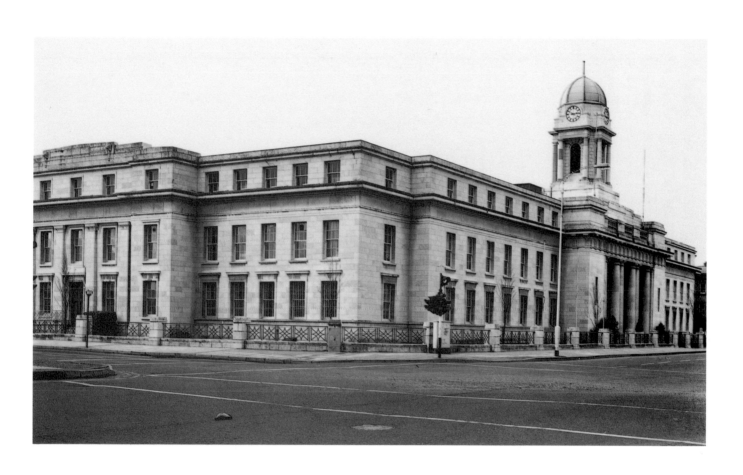

Looking Northwest from the Harbour

From a vantage point on top of the grain silos on the southern side of the river there is a panoramic view. In the foreground the two channels of the river converge. This explains why the city can be confusing to visitors who constantly seem to be encountering some branch of the river. In the distance can be seen the wooded slopes above Sundays Well.

Facing page: The confluence of the north and south channels of the river Lee.

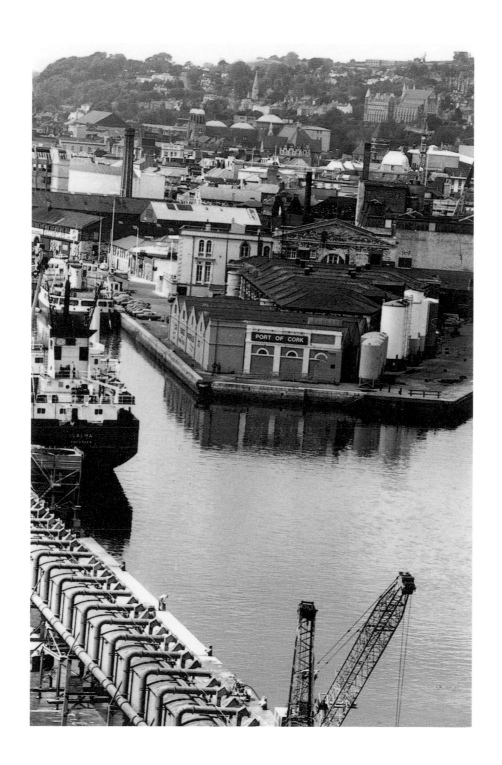

Cork Harbour Commissioners

Until the two bridges serving the new ring road were built this attractive building was effectively hidden from view and many Cork people would not even have known of its existence. The building started life in 1814 as a custom house. Later it was taken over by the Harbour Commissioners. The Cork Coat of Arms replaced the Royal arms which were originally there.

The Harbour Commissioners deal not just with docks and shipping but have jurisdiction over the entire harbour area which stretches for thirteen miles. It is the biggest harbour in the country and is considered to be one of the finest natural harbours in the world.

Facing page: Part of the elegant facade.

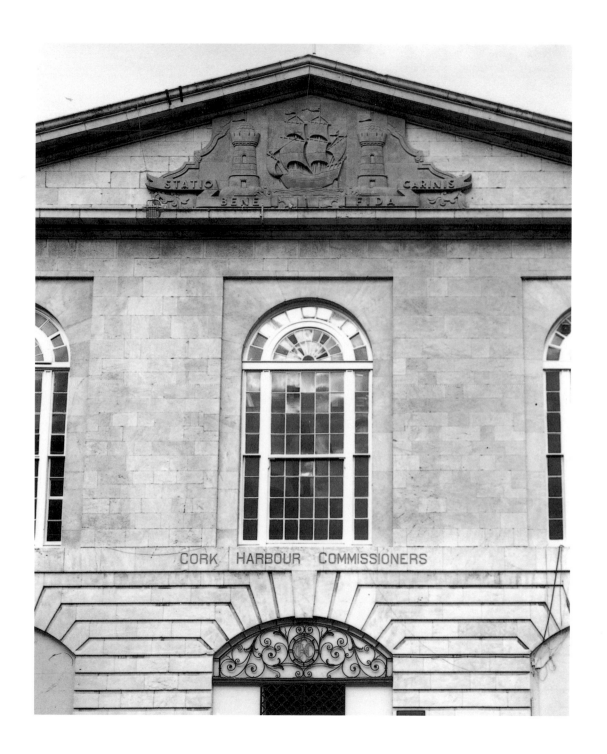

Boardroom

The boardroom is one of the finest and most elegant in the country, with a magnificent plaster ceiling.

Facing page: The ceiling of the Harbour
Commissioners' Boardroom

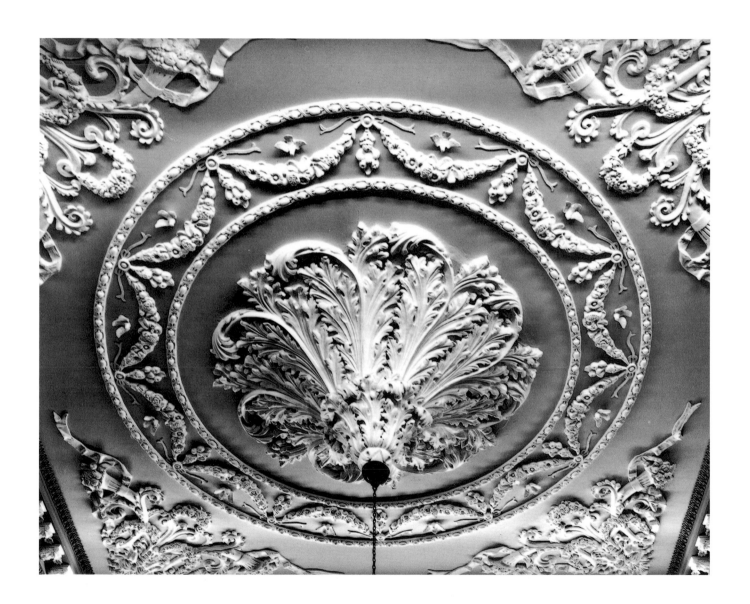

Bonded Warehouses

The bonded warehouses in the custom-house yard always seem more like a prison than stores, with the barred windows and the circular tower which looks strikingly like a watch tower. The grim appearance is relieved by the use of the typical mixture of local limestone and red sandstone.

Facing page: The cobbled yard around the warehouses.

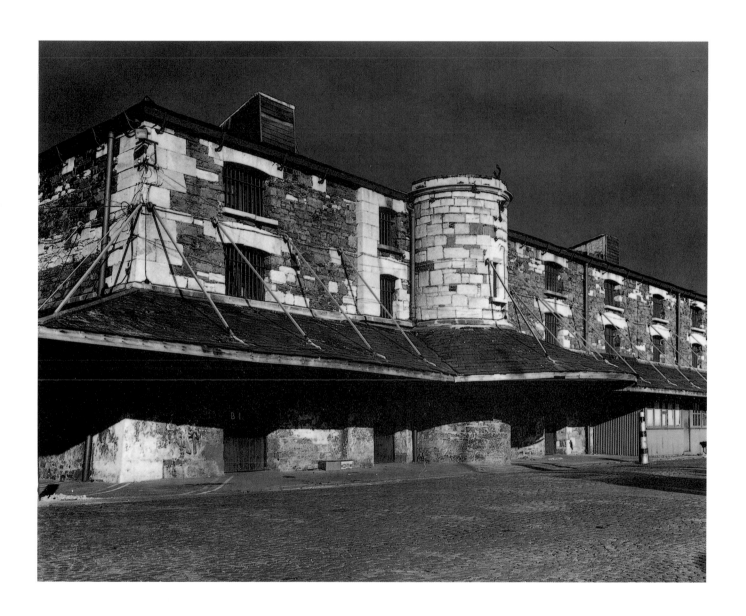

City Quays

In recent years much shipping activity has moved to the lower docks at Tivoli and Ringaskiddy which are geared for modernised container traffic. The huge grain silos with their attendant flocks of pigeons, on the southern branch of the river, are a familiar city landmark. Large ocean-going vessels are still regular features of the city quays. To allow these ships access to the city the early harbour commissioners had to carry out considerable dredging operations. These activities created large quantities of spoil and some of this was used to create the attractive tree-lined area known as the Marina.

Facing page: Grain silos and ships on the quays.

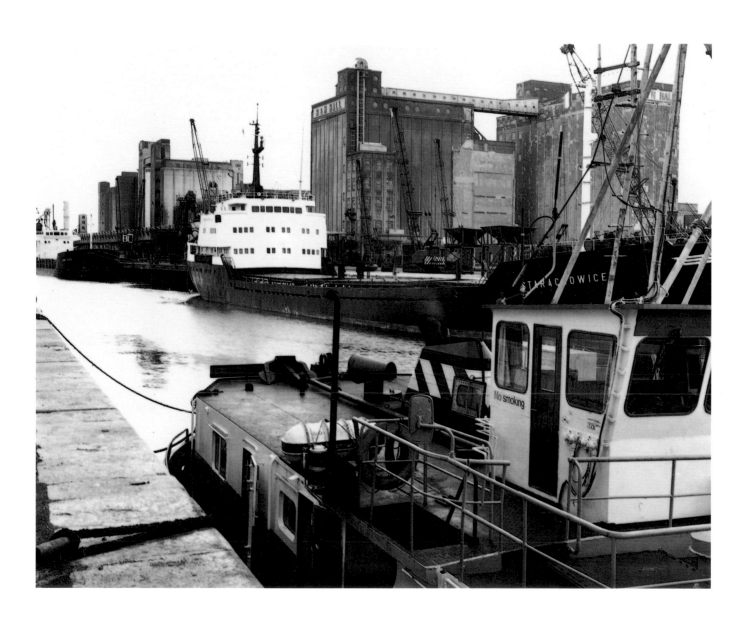

The South Terrace

To Corkonians the South Terrace seems to be as old as any other part of the city. However, until 1769 it was waste slob-land. It later became a most desirable address, the episcopal palace being located at number 32. One of its most famous occupants was Bishop Webster, the educationalist. While many famous people have lived here, for most people it will be remembered as the location of Mrs. Harvey's nursing home where numerous Cork people first saw the light of day. The area is the location of the Jewish Synagogue which serves the spiritual needs of the city's now tiny Jewish community. Trends change and the South Terrace is again the scene of revitalisation with a mixture of office accommodation and apartments.

Facing page: The new and the old on South Terrace.

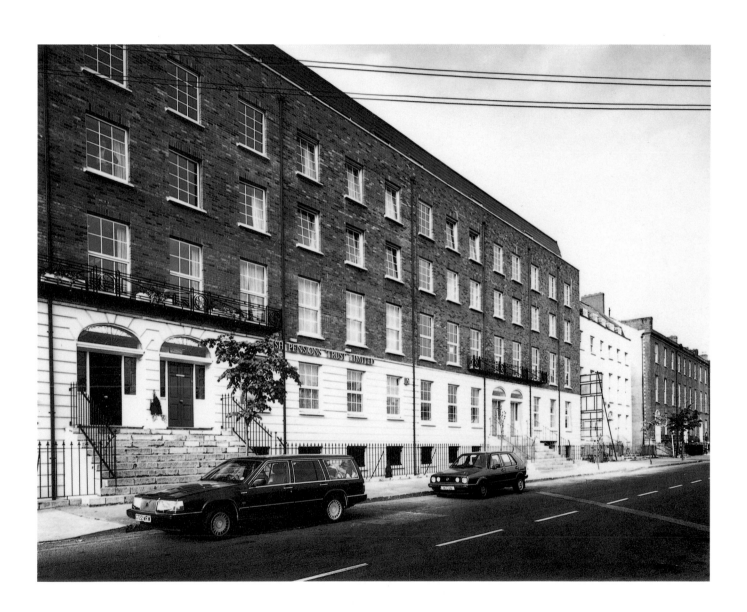

South Terrace

A sense of more elegant times is suggested by this rather attractive Georgian doorway. While the door has been maintained it is hard to imagine that in its heyday the staining on the steps would have been tolerated for long.

Facing page: Georgian doorway and steps.

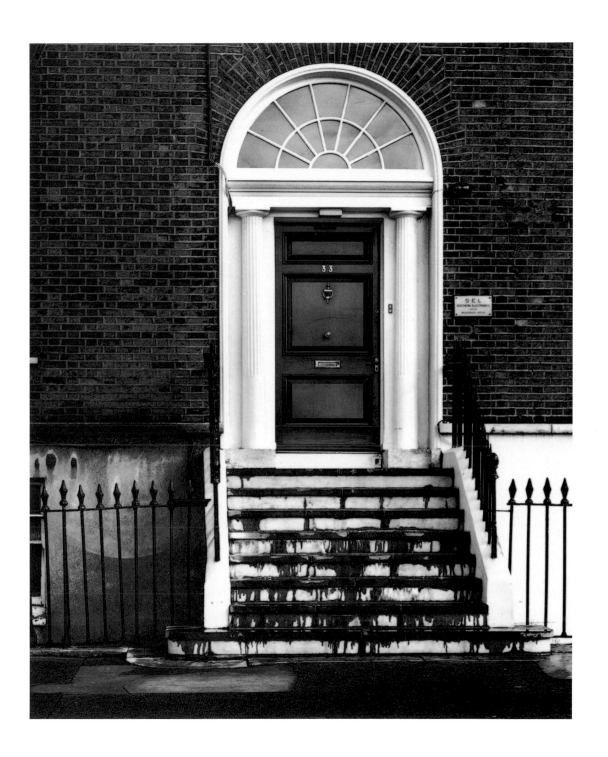

Christ the King Church

Churches and public buildings were traditionally stone built and were the major source of employment for local stone masons. There was great consternation when it was announced that the new church in Turners Cross was to be built of concrete. In his book "Stone Mad", Seamus Murphy, R.H.A., tells about his fellow stone masons getting up a delegation to protest to the bishop. Obviously their protestations fell on deaf ears and this most modern and daring of churches was built. It was the design of Barry Byrne, a Chicago architect, who never saw his building erected as the work was supervised by local architects. It is basically a large elliptical building with a vast roof area unsupported by any pillars. It was a most unusual design for its time. The exterior is dominated by a modernistic carving of Christ dividing the main portals.

Facing page: The main entrance to Christ the King Church.

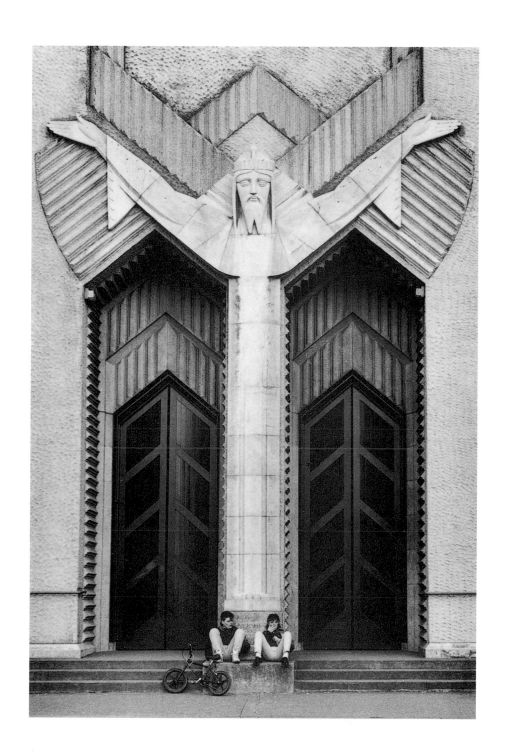

The Lough

One of the most underappreciated areas in the city is the Lough. This large, natural lake is a wildfowl sanctuary and during the winter months it provides a home to birds from colder, more northerly climes.

Occasionally, during very cold winters, the water freezes and for a short period becomes an outdoor skating rink for the daring.

All year round people give food to the birds which become tame and feed from peoples hands.

A local legend tells how the Lough was formed. The story goes that originally there was only a well on the spot. However, one evening a princess went to the well for water and forgot to seal it after her. During the night the well overflowed swallowing up her father's castle, drowning everybody in it and creating a lake.

Facing page: Feeding the swans at the Lough.

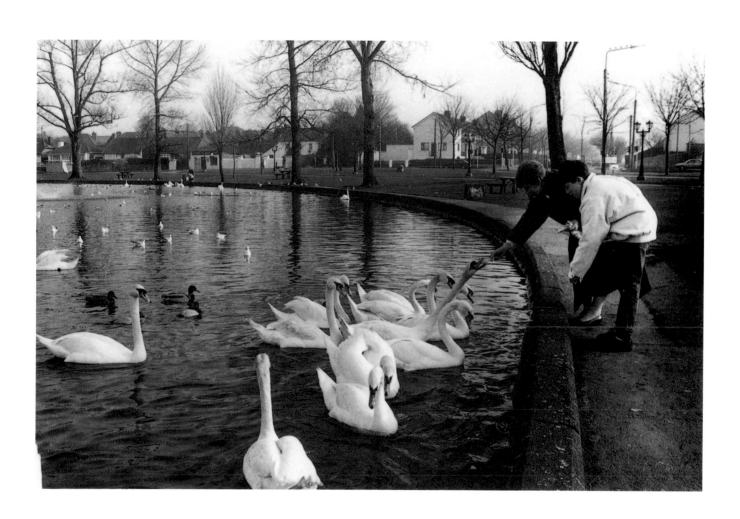

The Red Abbey

The exact age of this building is uncertain but it seems to predate 1545. At that stage it was known as Saint Austin's and how it acquired its name as the Red Abbey is not clear. It was an Augustinian friary and not an abbey as such. It is thought that local red sandstone could have been used in the building of the now disappeared church but there is no trace of sandstone in the surviving tower.

The abbey, like so many buildings of its kind, has had a chequered history. During Cromwell's stay in the city his soldiers used it as a stable for their horses. This was his method of showing disrespect for his opponents' religious beliefs. In the latter part of the seventeenth century it was used as a barracks during the Williamite wars. It later became a sugar-refining factory known as the "Red Abbey Sugar House". It reached the end of its life on the seventh of December, 1799, when it was destroyed by fire. The remains are looked after by the corporation.

Facing page: The surviving tower of the Red Abbey.

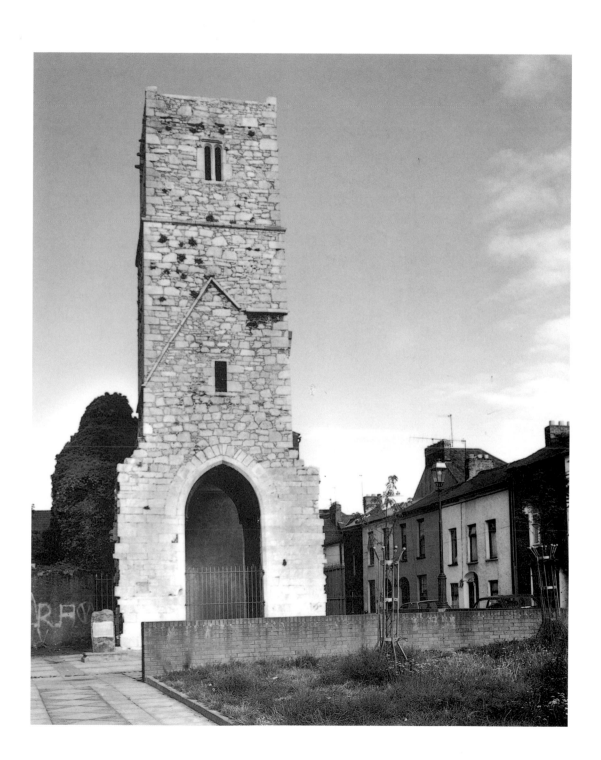

The Spire of Saint Nicholas' Church

Tucked away in Cove Street is the old church of Saint Nicholas. This attractive limestone building is hidden amidst the houses and cottages of the area. From the Evergreen Road all that can be seen of it is the spire which soars above the cottages.

Facing page: Cottages and spire.

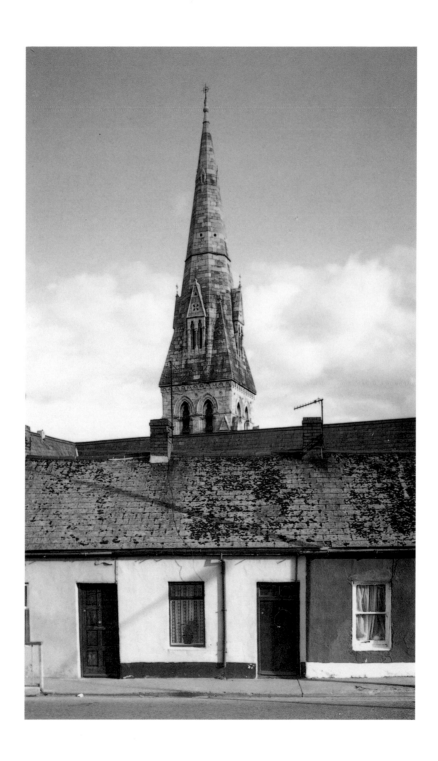

Saint Fin barre's Cathedral

In 606 A.D. one of the main monastic schools in Ireland was established on this site. It was set up by St. Finbarr (from the Irish "fair haired"), and to this day the area has been involved in the religious life of the city. There have been numerous churches and cathedrals on this site. Among the treasures of the cathedral is a silver gilt chalice from 1563. Over the centuries the cathedral has seen many turbulent occasions and during the siege of Cork in 1689 the cathedral was badly damaged. In the ambulatory of the present building there is a 24lb cannon ball which was found when the previous smaller cathedral was demolished in 1865.

In 1862 William Burgess, the architect, was appointed to design the present cathedral. His building, which was completed in 1879 at a cost of £40,000, exceeded the initial expected cost by nearly 300%.

The building is mainly of local limestone and red Cork marble is used to line the walls as well as for the font.

Facing page: View of the eastern elevation as seen from the South Gate area of the City.

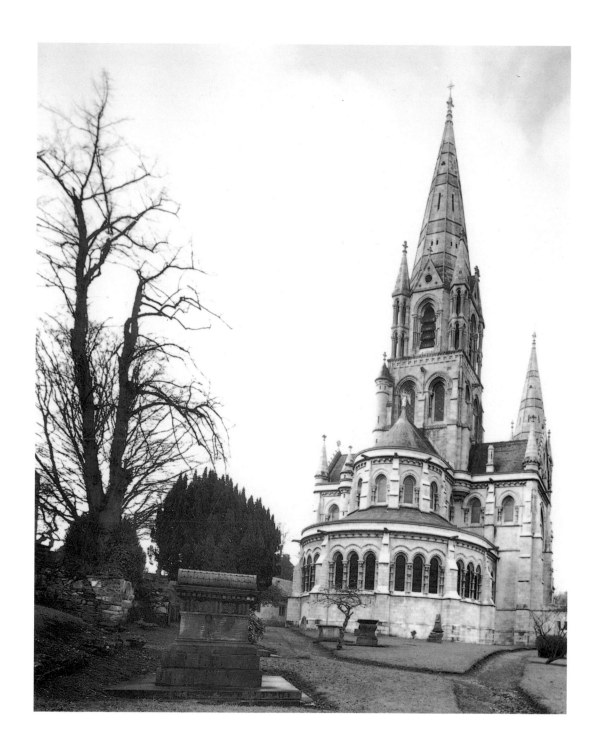

Cathedral Interior

This view of the interior of the cathedral shows the attractively painted ceiling. Just inside the altar rails can be seen the Bishop's throne which is forty-six feet high and carved from oak. Twenty of the most prominent bishops of the diocese have their likenesses engraved onto the throne. The floor of the sanctuary has a lovely mosaic covering on the theme of "fishers of men".

Facing page: Looking up the nave to the main altar.

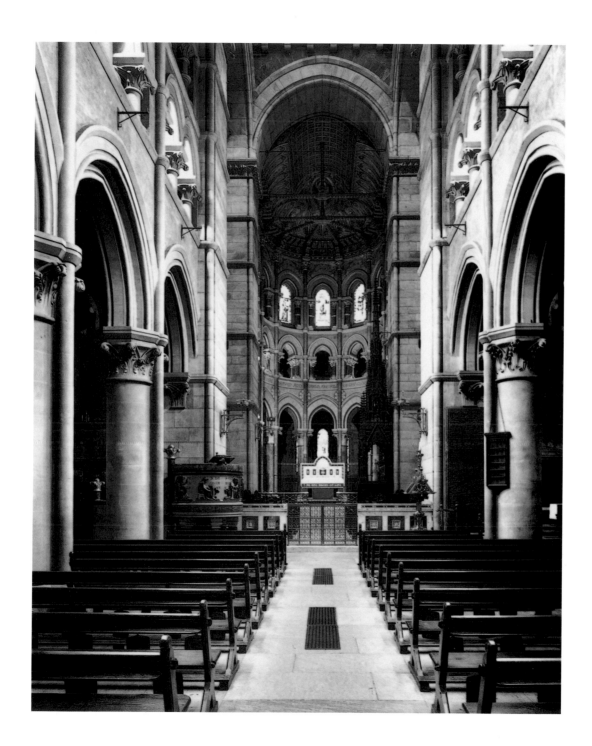

The Golden Angel

This statue has endeared itself to generations of Corkonians and has attracted a number of legends. One of them is that the end of the world would be signalled by the blowing of the angel's trumpet. Another story is told by Patrick Galvin in his book "Song for a Poor Boy". He tells how he was reared with the belief that before the end of the world the angel would turn green. Despite the keen ears and observations of generations, the trumpet remains mute and the angel ever golden.

Facing page: "The Goldy Angel".

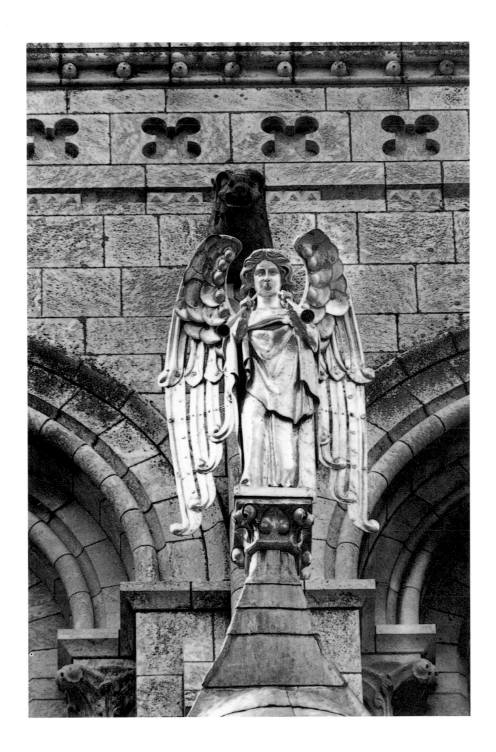

Gargoyles

On the west side of the cathedral, above the doors, are some finely-carved gargoyles which represent the conflict and triumph of virtue in the soul of the Christian. Virtue is seen as a female overcoming the vices. Can we draw the inference from this that the figures representing the vices are male!

Facing page: Faith piercing the eye of Idolatry.

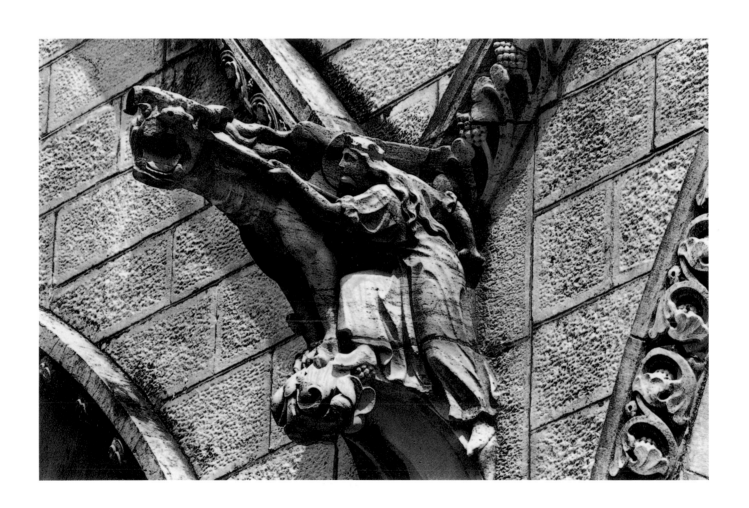

University College Cork

In 1845 universities were incorporated in Belfast, Cork and Galway and they were known as the Queens Universities in Ireland. They were developed to provide educational opportunities for the children of middle class people. Previously it was only the sons of aristocrats and the landed gentry who went to university. At one stage Jews, Catholics and Protestant Dissenters were barred from higher education. The selection of the site for the university was undertaken by the board of works and maybe it is not just a coincidence that they located the collegiate buildings on an outcrop of rock just upstream from where Saint Finbarr formed his monastic school. The board of works supervised the construction of the university. Some eight months after the building was completed and handed over to the college, the Registrar wrote a letter complaining that the Bursar's office still didn't have a door. The student body now numbers thousands and all branches of education from the humanities to the sciences are catered for.

Facing page: The north face of the main buildings.

The Jail Gates

Adjacent to the university was one of the city jails. During its lifetime many famous people were held there including some of the Fenian Leaders while they were awaiting sentencing. During more recent times the revolutionary Countess Markievicz had a couple of stays there. In calmer times there was a falling off of trade for the prison and in 1958 it was given to the university authorities who demolished the old jail buildings and developed their science department there. They were obliged to retain the Greek Doric portico which had been modelled after the temple of Bacchus in Athens. To the left of the old prison entrance can be seen a gateway. This was the original entrance to the college. It was felt that it was not proper for staff and students to have to enter by a gate next to a prison and, accordingly, the more impressive entrance on the Western Road was developed.

Facing page: The Jail portico and the Jail Gates entrance to U.C.C.

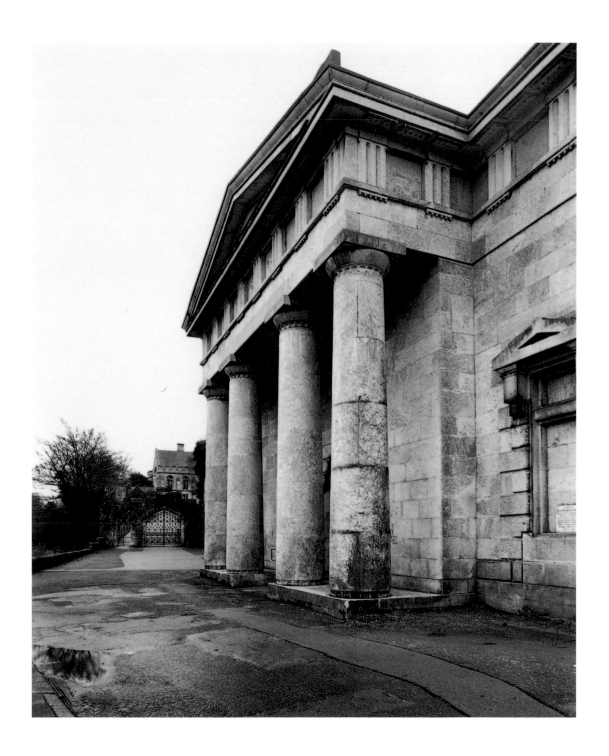

The Stone Corridor

In the North Wing corridor of the quad in U.C.C. are a number of ogham stones which were unearthed around the country. One of the most interesting was unearthed in County Cork by a farmer digging his potatoes. The corridor is popularly known as "The Stone Corridor".

Facing page: The view along the stone corridor

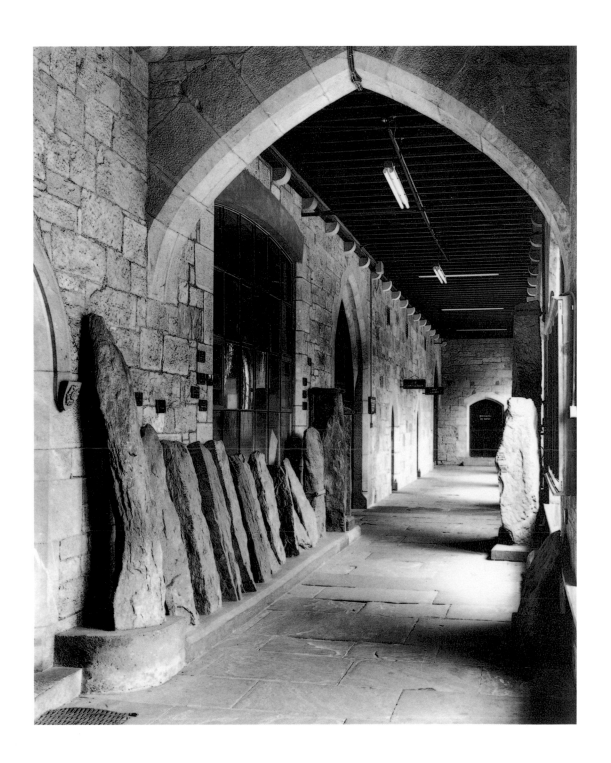

The Boole Library

With the massive increase in the numbers attending the university one of the problems the authorities had was the provision of a modern library. This library was developed and named after George Boole. He was the famous mathematician whose system of algebra laid the foundation for modern computer logic. As well as having a library of 600,000 volumes, facilities are also provided to enable students to study. The library occupies the site of an old quarry in which a soccer pitch used to provide on-campus entertainment, especially during the "Quarry Cup" competition.

Facing page: The modern facade of the Boole Library.

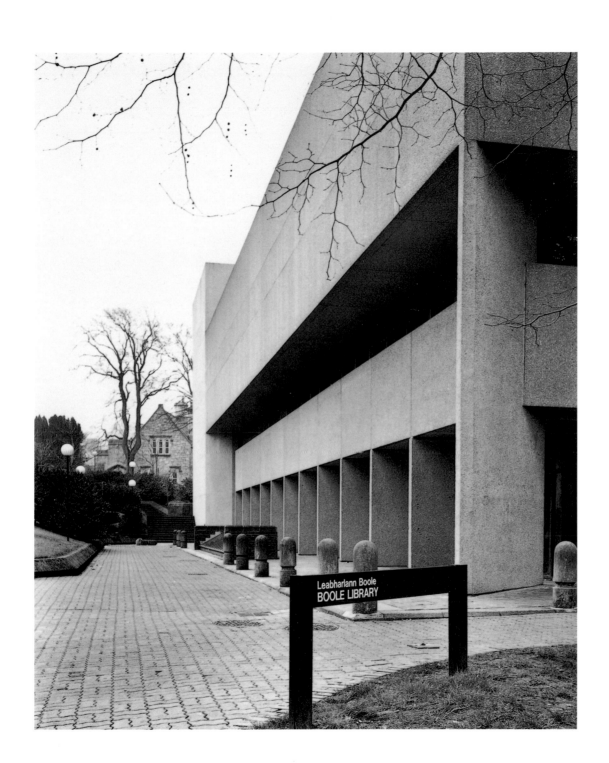

Fitzgerald's Park

This is the oldest and largest of the city parks. During 1902 and 1903 Cork was the venue for an international exhibition. When the exhibition closed the organisers were left with the question of what to do with the site. Eventually it was given to the corporation, developed into a public park and named after Sir Edward Fitzgerald. It is a mixture of formal gardens, open spaces and a large recreation area.

The pond, with its surrounding walk and seats, is a focal point and a meeting place for young and old alike.

Facing page: "Boy and boat" by Joe Higgins.

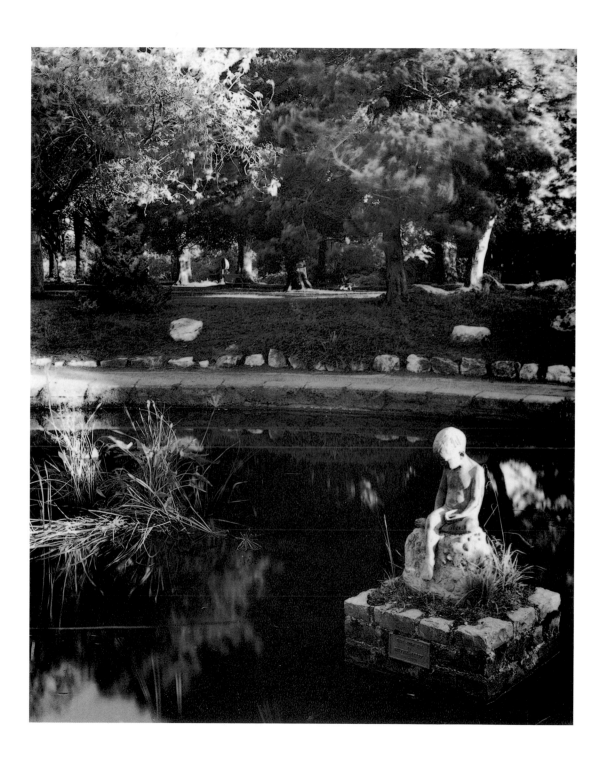

Sculpture

As a result of the activities of the Cork Sculpture Park Committee a section of Fitzgerald's Park has been turned into an open air venue for sculpture. This allows visitors and locals alike who are relaxing in the park to view and appreciate these works of art.

Facing page: "Dreamtime" by Seamus Murphy R.H.A.

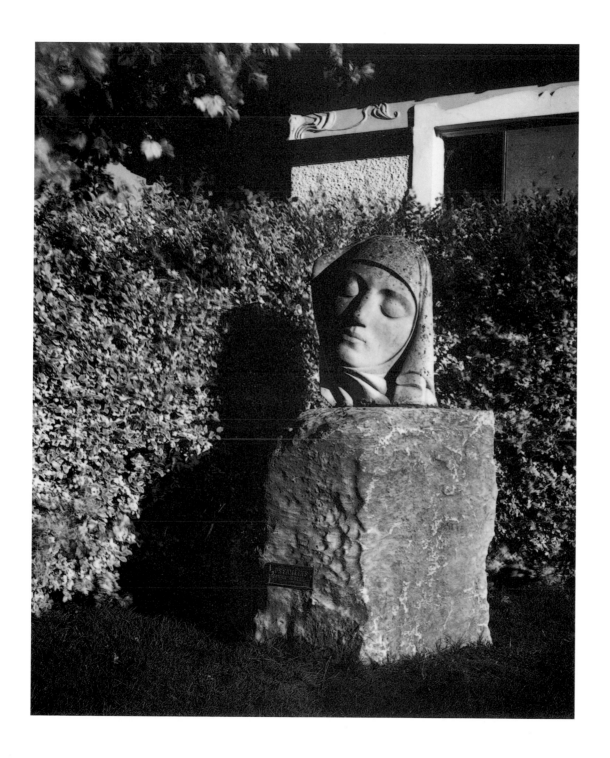

Playing Cricket

An idyllic way to spend a summer afternoon is to sit in the shade of a cricket pavilion and watch young men giving of their best. The pleasure of the day is enhanced by the setting with Sundays Well rising in the background.

Facing page: An energetic pastime on a hot afternoon.

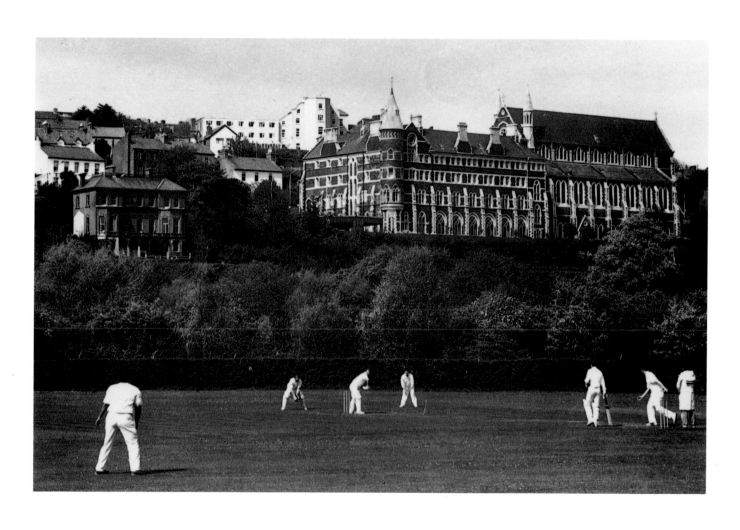

The Mardyke

Adjoining Fitzgerald's Park is the Mardyke. This was laid out as a tree-lined boulevard with a small stream running along one side. The city fathers closed in the stream and in recent times the dreaded Dutch Elm disease necessitated the removal of the old trees. James Joyce visited the area and wrote that "The leaves of the trees along the Mardyke were astir and whispered in the sunlight". It would be nice to see the old spot restored to its former grandeur. This was a popular residential area and there are still Georgian houses with their wrought iron railings and balconies.

Facing page: A Georgian facade on Dyke Parade.

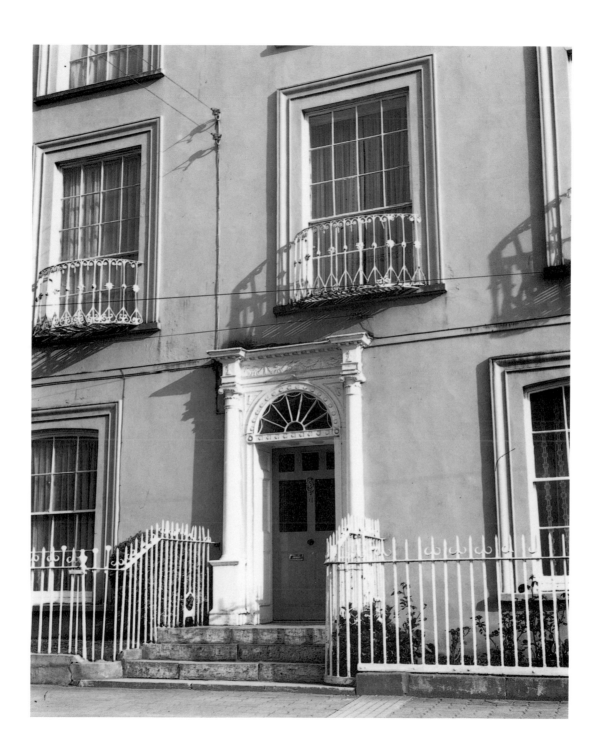

The Old Women's Jail

This building, which received its first prisoners in August 1824, was built as the city jail. Prisoners of both sexes were housed there and it only became a women's jail in the 1890's. It was a general purpose prison mainly inhabited by debtors and vagrants. It is interesting to note that class distinction extended down as far as debtors. Accommodation was divided into sections for pauper debtors and gentlemen debtors, with the latter being better fed and treated.

In those days, too, prostitution was a problem and a section of the prison was reserved for women of "the unfortunate class". One particular lady seems to have been very unfortunate as the records show that she had twenty visits in one year.

The jail was also used to house Fenians and several well-known men were held there while awaiting transportation. The first governor was a Mr. Barry Murphy whose descendants have achieved fame on the sports field. In the late 1920's the building had a happier history when it was taken over as a local studio by the then fledgling national radio station. It functioned as their Cork studio for some years. More recently the building has lain derelict and at the moment the corporation are considering proposals for various uses.

Facing page: The imposing facade of the Women's Jail.

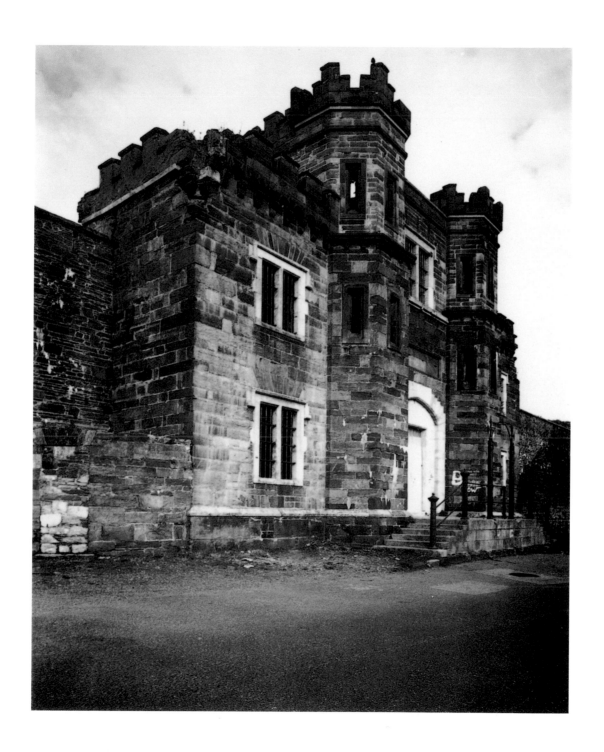

The Courthouse

Prior to 1835 Cork had two courthouses, the city courthouse and the county courthouse. The county courthouse stood on the site of the present Queens Old Castle shopping mall and some of it was incorporated into its facade. Later the two courthouses were incorporated into this building, which was opened in 1835, on Washington Street.

Considered the finest neo-classical building in the south of Ireland, it was badly damaged by fire in March 1890. This new building opened in March 1895. Over the portico was a blindfolded statue of Justice. In one hand she held the scales of justice, in the other the sword of justice. The blindfold indicated that justice would be administered impartially, the scales indicated evenness and the sword was a symbol of justice being applied.

During the 1920's the sword and scales were removed by people who felt that justice was not being evenly applied. Recently the statue itself was removed as it had fallen into disrepair.

In his book, "Old Munster Circuit", Maurice Healy relates that at the formal opening of court sessions the judges went in procession from their lodgings to the courthouse. They were escorted both by the Royal Irish Constabulary and by a section of a cavalry regiment from the local barracks. Healy recalls that if the crowd became unruly the cavalry men would restore order with the flat sides of their swords. It appears that the members of the judiciary were not always universally popular.

Facing page: The Courthouse portico on Washington Street.

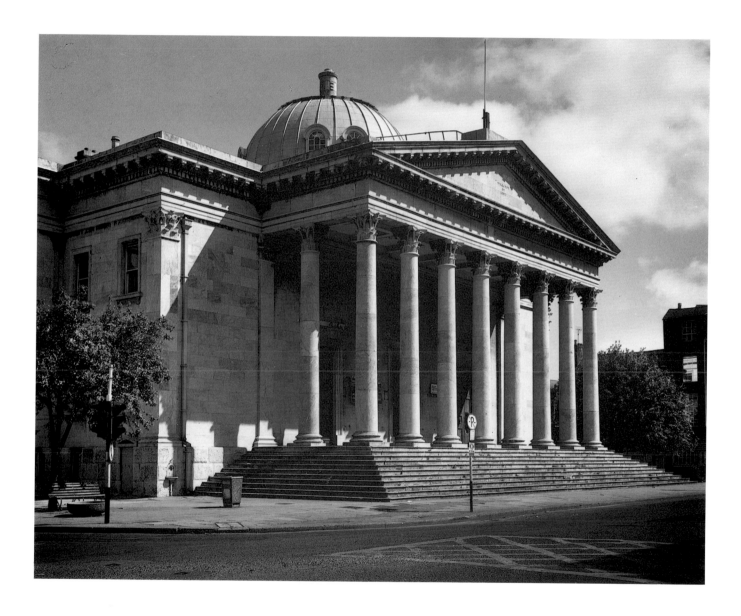

Cross's Green Quay

This spot is now a rather quiet backwater. Milling, fishing and the other businesses which traditionally flourished here have either closed or moved to other locations. Even the fishermen no longer ply their craft here. The area hasn't changed with the times and it can be imagined that should one of the deceased locals pay a visit the surroundings would still be very familiar.

Facing page: The river at Cross's Green Quay with Barrack Street in the background.

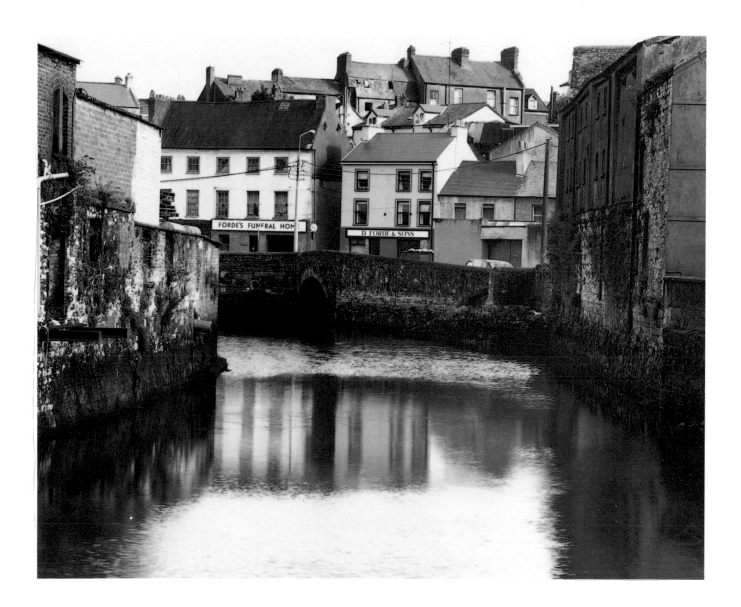

Pubs

No Irish city would be complete without its interesting pubs. One of the more pleasant public houses in the city is located in Hanover Place. The name over the door says O'Flynns but it is more affectionately known as " The Morgue ". Whilst pubs tend to be given nicknames by their patrons this is a rather unusual one. It got its name from the fact that a nearby weir in the river tended to trap the bodies of drowning victims as they were being swept downriver. In the days before incidents like this were looked after officially and quickly, the tradition grew up of bringing the bodies to this premises while awaiting officialdom to swing into action.

Facing page: The renovated interior.

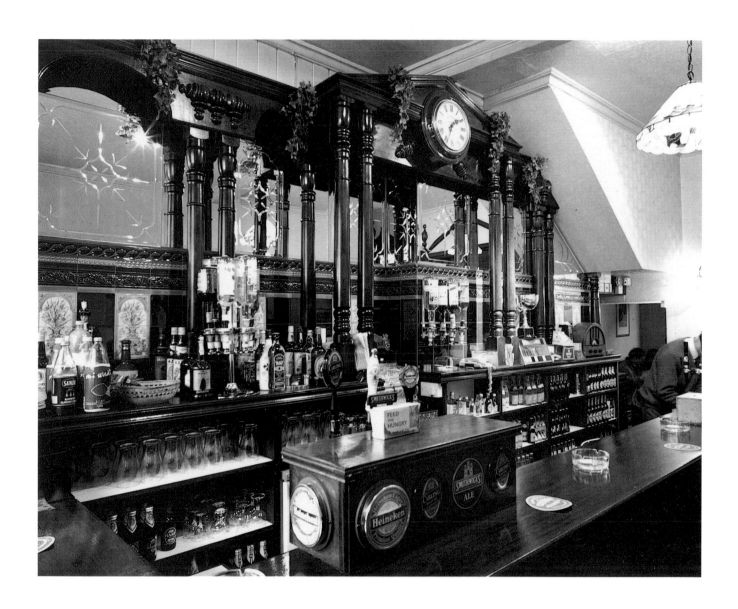

Union Quay

Union Quay starts off with a choice of public houses each attracting a clientele of its own. The individuality of the establishments is reflected by the names.

Facing page: A sample of pub names from the area.

donkeys Ears

CHARLie'S

An Phoenix

S.H.A.R.E.

Seminars are not usually known to be the originators of great ideas. There is always the exception to the rule. One such seminar in Cork in 1969, on the theme of "Poverty Today", inspired some boys from fifth year in Presentation College to set up a crib in Patrick Street and have a sponsored fast. From this beginning the boys of this school have, with the aid and assistance of Cork Corporation, provided 112 houses for the elderly and flats for another 36. Their most recent development has been Dún Rís in Grattan Street which gives sheltered housing for 36 people. This building is modelled on the old-style cloister with an ambulatory on the inside.

Facing page: Dún Rís

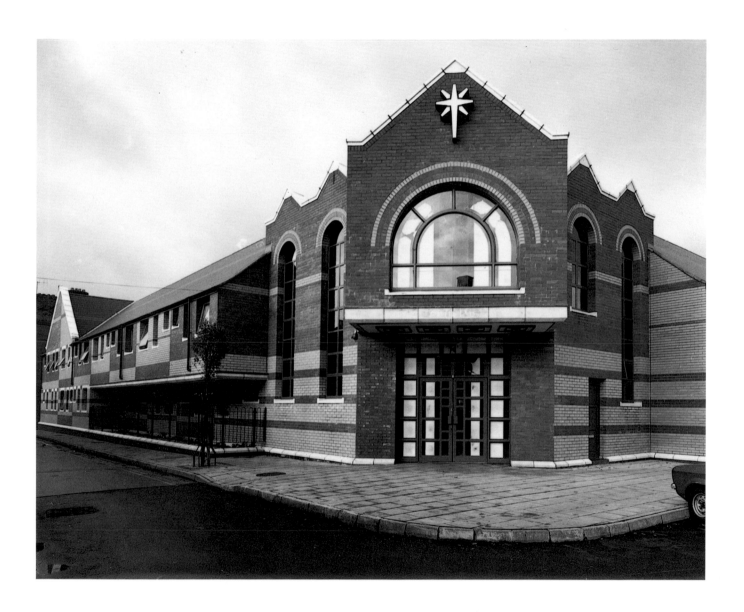

Sheare Street

One of the old areas of the city which has not yet been redeveloped is this part of Sheare Street. It is an unusual mishmash of old furniture shops, pet shops and bric-a-brac stores. They give a Dickensian air to the locality but their days may be numbered as the area is scheduled for redevelopment.

Facing page: Bric-a-brac shops

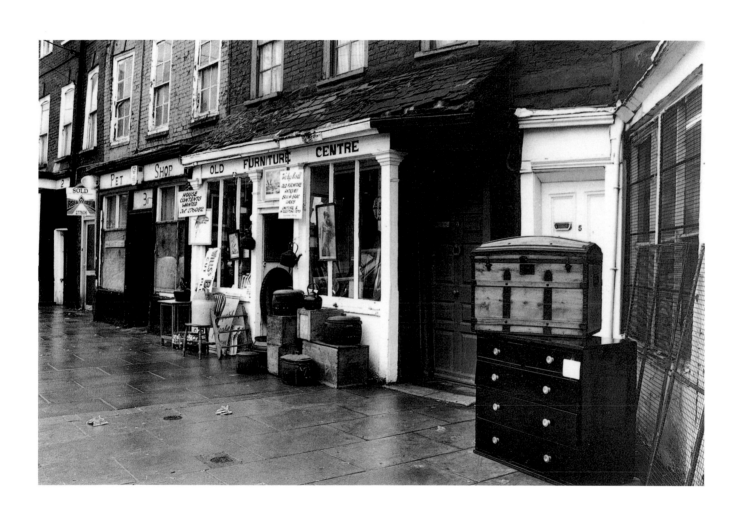

Second-hand Goods

Something very interesting seems to be going on down the street. The wide range of goods have lost their attraction.

Facing page: Difficult trading conditions

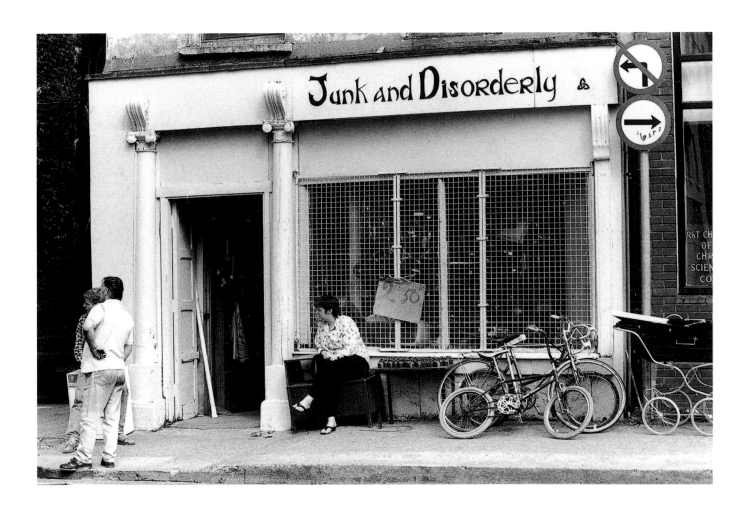

Portney's Lane

Looking at Portney's Lane today it is hard to visualise that it was one of the main thoroughfares of the old walled city. In the 1600's it was a fashionable address and, after the Battle of Kinsale, the leader of the unsuccessful Spanish forces was housed here before he was allowed to return to Spain. Perhaps he would have been better off staying in Cork as his master, the King of Spain, was not too pleased with him and he was executed. To this day people still live in this lane and they have painted the wall on the left side white to reflect the maximum amount of light into their homes opposite.

Facing page: A sunlit Portney's Lane.

Clothes Stall, Cornmarket Street

Despite the proliferation of boutiques and trendy clothes shops in the city, some people prefer to browse at the clothes stalls on the Coal Quay where bargains can be had.

Facing page: Searching for a bargain.

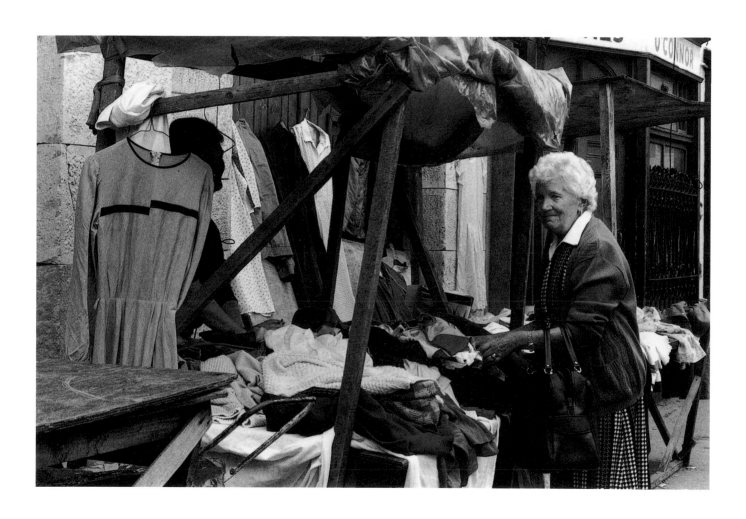

Furniture Store

This gentleman seems to be taking advantage of a lull in the busy days trading to catch up with what is happening in the world.

Facing page: Reading "De paper".

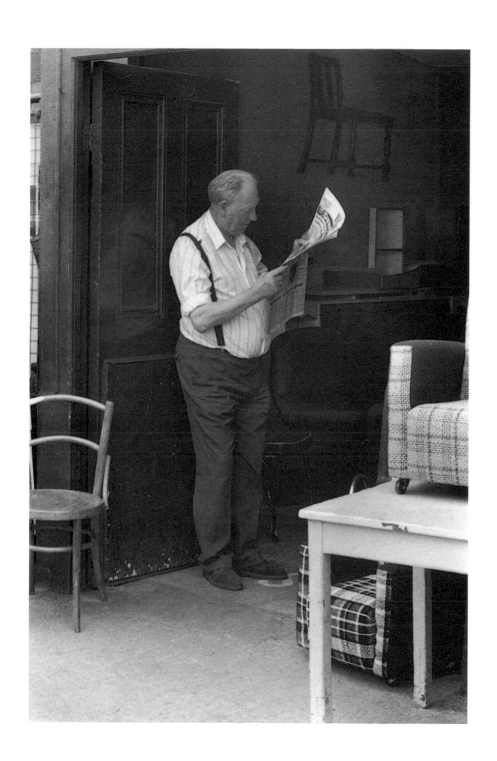

The Coal Quay

Cork would not be Cork without its open-air market called "The Coal Quay". To make the matter very much a Cork one this market doesn't take place on "The Coal Quay" at all but in nearby Cornmarket Street. The idea of the open air market started with market gardeners from outlying areas bringing in their produce to sell in the wide street. Over the years this evolved into a general market with stalls being passed down from generation to generation usually on the female line. It was formerly a place of great characters. The pubs were permitted to open early in the morning to cater for the traders and it was a lively spot. Shaw's Tourists Picturesque guide in 1881 said "The Coal Quay is a part of the city amusing enough to strangers, yet far too unfashionable for the respectable citizens to take much interest in". He also said that their speech was "graced with the wildest blossoms of southern rhetoric".

Facing page: A happy vendor.

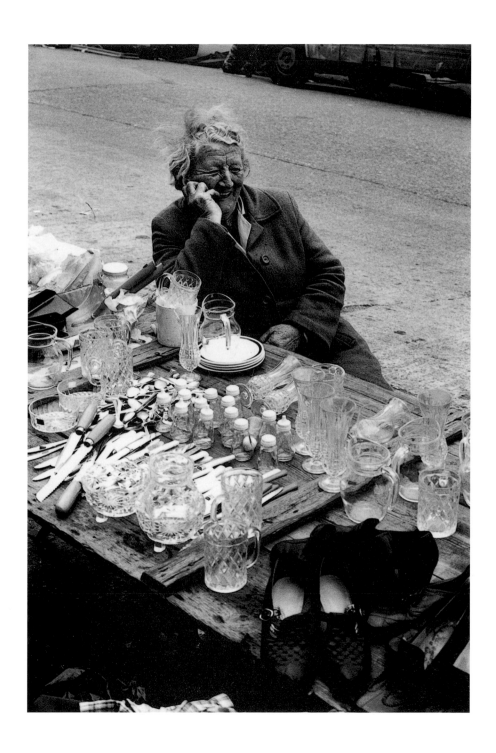

Old Ways

This is a sight which is rarely seen nowadays in city streets. The driver, having delivered his load, is presumably refreshing himself in a hostelry while the horse waits patiently for him. If a traffic warden was to arrive on the scene and see this horse tied to a no parking sign where would he put his parking ticket?

Facing page: Illegal parking?

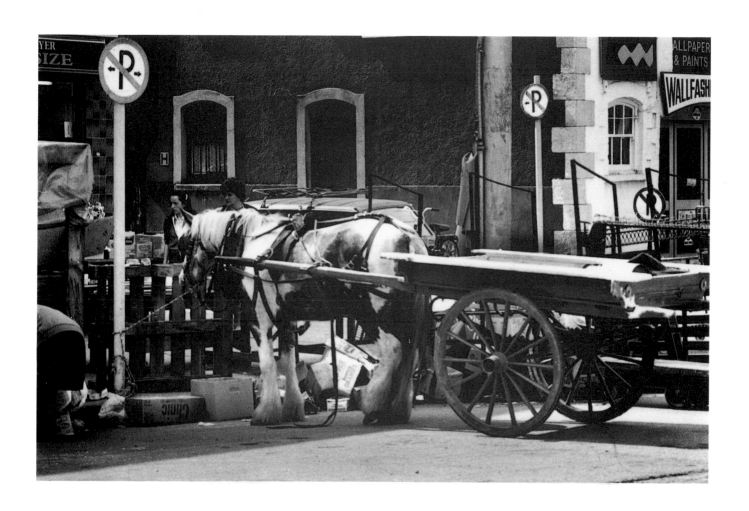

Bicycle Parking

The difficulty of finding secure parking for bicycles is highlighted by this picture.

Facing page: Some people have no respect for authority.

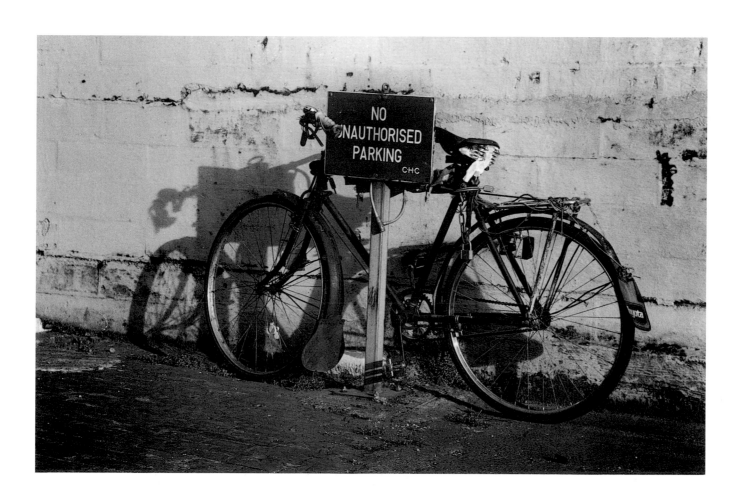

Inner City

One of the traditions of city dwellers was to take advantage of sunny days and to sit and chat on their doorsteps. These ladies are availing of such a sunny evening in Corporation Buildings. Perhaps the most famous tenant of these flats was Katty Barry who ran a crubeen shop and sheebeen in the area. Many stories are told about this lady. One is that, when on one occasion she was being prosecuted for after-hours drinking, the sternfaced judge demanded an explanation of her behaviour. She replied that she did not have to explain anything to him seeing as how he spent so much time in her premises when he was a law student.

Facing page: The pleasures of age.

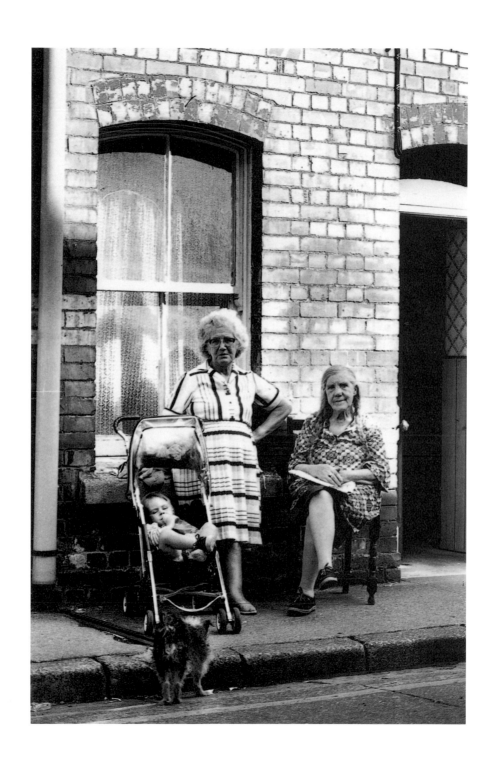

Keeping a Weather Eye

This little fellow immediately brings to mind the old song "How much is the doggie in the window?". For many years this dog, whose name was Judy, was the faithful friend of the late Mrs. Kitty Barrett of Corporation Buildings. She lived in a first floor apartment and her dog, as is common with so many of its type, loved to stand at the open window on a sunny day and watch what was going on outside.

Facing page: Judy

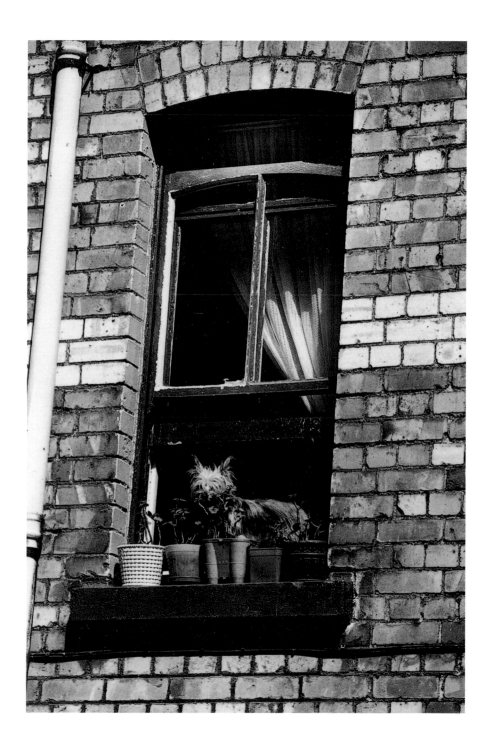

Grand Parade

The Irish for this street is Sráid an Capaill Bhuidhe. This name came from an equestrian statue which stood where the National Monument now stands. The statue was erected to honour a British monarch but it had a rather unfortunate history. As the monarchs changed different heads were put on the statue. After some years the horse started to lean over and a prop had to be put under it. Subsequently the statue itself started to topple and it also had to be propped. Eventually, horse and rider were removed.

The National Monument was erected by the Cork Young Ireland Society to honour various patriotic uprisings. The large building is the regional office of the Industrial Credit Corporation. Previously it had served as a gentlemens' club and was later owned by a religious organisation.

The three slate-clad, bow-fronted houses date from the eighteenth century.

Facing page: The junction of the Grand Parade with the South Mall.

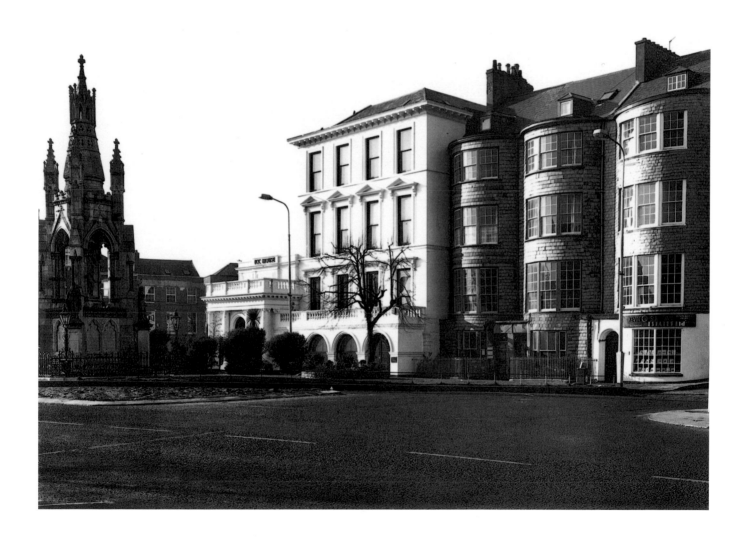

Berwick Fountain and Bishop Lucey Park gates

The Berwick Fountain was the first publicly-erected tribute to Father Matthew. Erected in 1860 it was paid for by Judge Berwick. The inscription around it says that it was in thanks for the kindnesses shown to him by all classes of people in the city. Unfortunately the fountain wasn't universally appreciated. A local ballad of the time commented:

*"But Mavrone, all the labour and money was lost,
for it scatters the water which comes from its top,
and 'twill wash down your shutters, thus saving a mop.
While it works, try to pass it with shining silk hat,
and 'tis clear of the fountain you'll keep after that"*.

Behind the fountain are the large gates forming the entrance to Bishop Lucey Park. These were originally the gates to the haymarket in Anglesea Street. After this market closed down it became part of the yards owned by the corporation. When this area was being developed the gates were taken down and re-erected here.

Facing page: The Fountain and Gates.

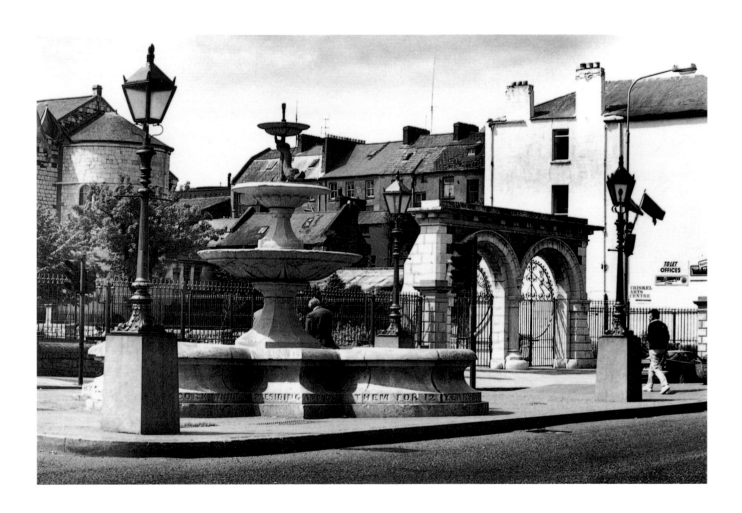

Old City Wall and Archives

When Bishop Lucey Park was being developed a section of the old city wall was uncovered and made into a feature of the park. To remind people that the city was built on a series of islands in a marshy area a moat was provided on either side of the wall. The city archives, located in Christ Church, provide a very suitable backdrop.

Facing page: Old City Wall.

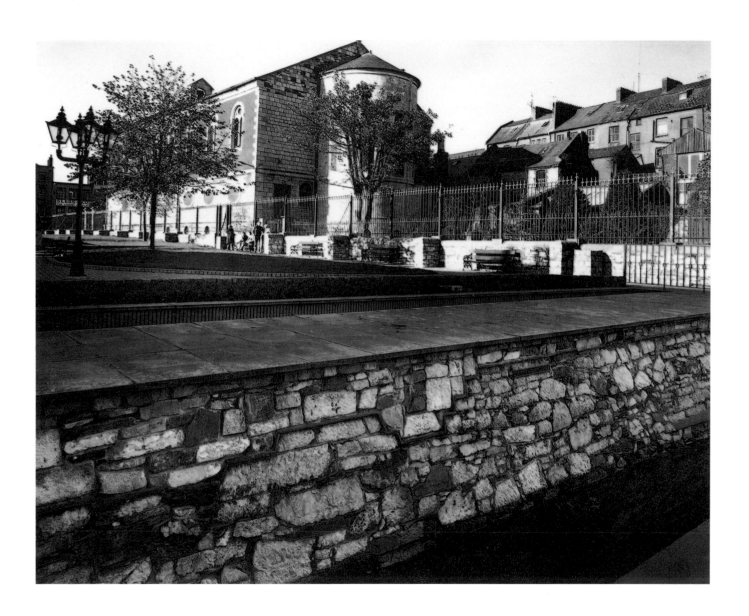

Park Sculpture

On a pleasant afternoon Bishop Lucey Park attracts many visitors who enjoy the sunshine in tranquil surroundings. The centrepiece of the park is a large fountain by the sculptor, John Behan. It takes the unusual form of eight swans in flight with the water cascading over their wings. In the foreground is an equally famous sculpture by Cork's best known sculptor of this century, Seamus Murphy R.H.A. Its title is "The Onion Seller".

Facing page: A view of the park.

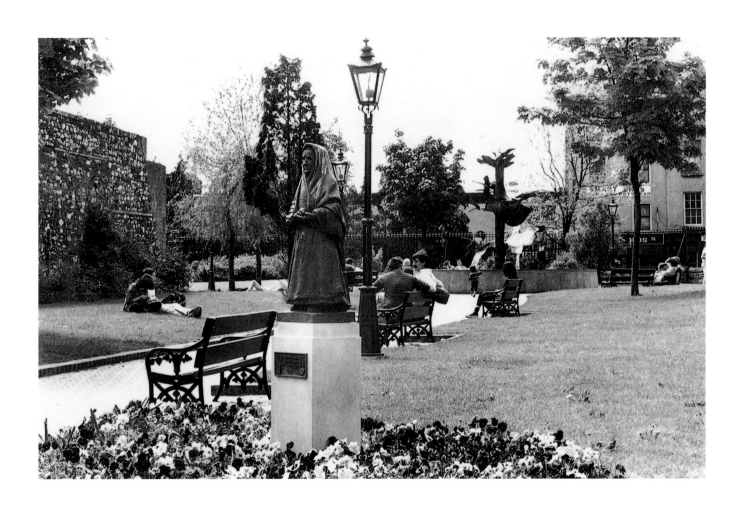

The Queens Old Castle

The western end of Patrick Street commences with a sweeping curve from Grand Parade. The buildings on either side frame the Queens Old Castle Shopping Centre. In the early days of the city there was a castle on this site and that was succeeded by the county courthouse. The front of the courthouse has been incorporated into the facade of the present building. It was in this old courthouse that the barrister Daniel O'Connell successfully defended some loyal insurgents after his famous non-stop ride from his home in Derrynane, County Kerry.

Facing page: A quiet morning outside.

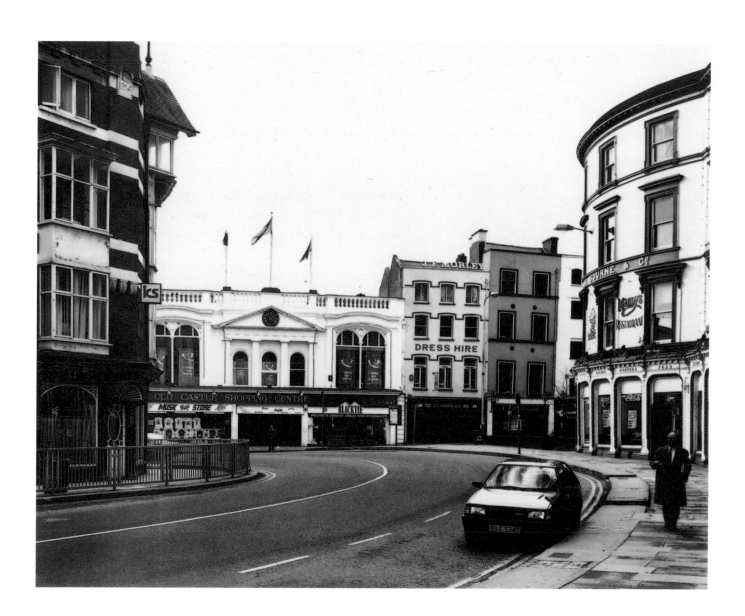

Market Lane

The narrow passageway known as Market Lane joins Patrick Street with the market. This laneway which is partly arched over contains two of Cork's oldest and most famous hostelries. They are the Vineyard and the Oyster Tavern. The fame of the Oyster was so widespread that after the last war it was not unusual for gourmets from ration-controlled England to fly into Cork for a steak at the Oyster.

Facing page: Looking down Market Lane from Patrick Street.

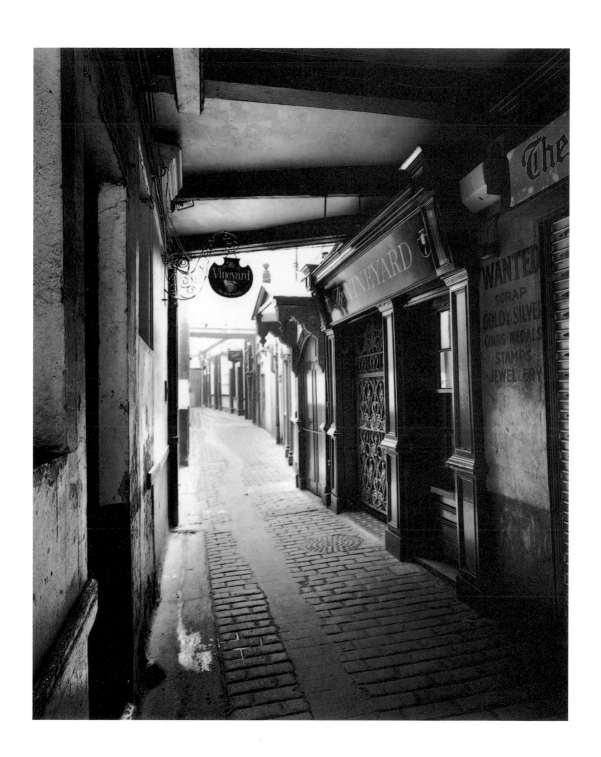

S.S. Peter and Pauls

This lovely Gothic-style church was designed by the famous architect Pugin. It is built out of local red sandstone and white limestone was used for ornamentation. The foundation stone was laid in 1859. This section of the city was bordering on an area known as "The Marsh", which was a rabbit warren of lanes teeming with hovels and underfed, poorly clad people.

Yet the funds were raised for this magnificent building and it was a matter of great pride to its parishioners. It is a pity that it is approached by a narrow street since its beauty would be better appreciated in an open area.

The man charged with supervising the construction was the Venerable Archdeacon J.J. Murphy. His must have been a rather late vocation, his career prior to ordination having ranged from participating in the Battle of Trafalgar with the Royal Navy to being a fur trader in Canada and being made an Indian Chief. He returned to Ireland, took up Holy Orders and during the famine period worked in West Cork, one of the most affected areas. He was subsequently appointed Archdeacon of his native city and this building stands as a tribute and monument to a most unusual gentleman.

Facing page: S.S. Peter and Pauls Church.

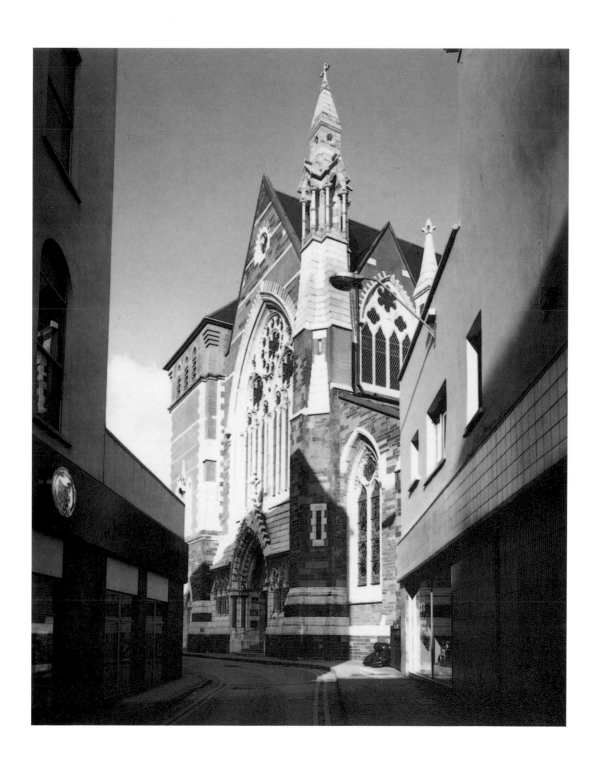

Pedestrianisation

Until recently some of the old laneways leading from Patrick Street were neglected. With the development of the nearby shopping centre new life has been injected into the district. Carey's Lane is a good example of how new shops and restaurants can be fitted into the old buildings. The corporation has pedestrianised the lane and laid an attractive brick pavement.

Facing page: The Collins Bookshop on Carey's Lane.

Busking

While music has always played an important part in the life of the city, it is only recently that there has been an explosion of street musicians. They lend a continental air now that some of the city centre cafes have taken to setting out tables and chairs in the summer. It adds an air of gaiety to the streets.

Facing page: Graffiti and music

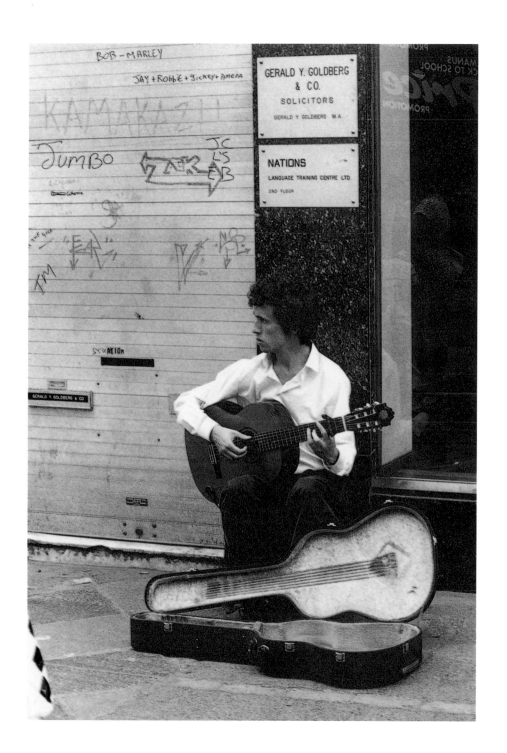

Pray Now, Saved Later

A regular feature of the city streets is the person who stands silently offering tracts to passers by.

Facing page: Saving tickets

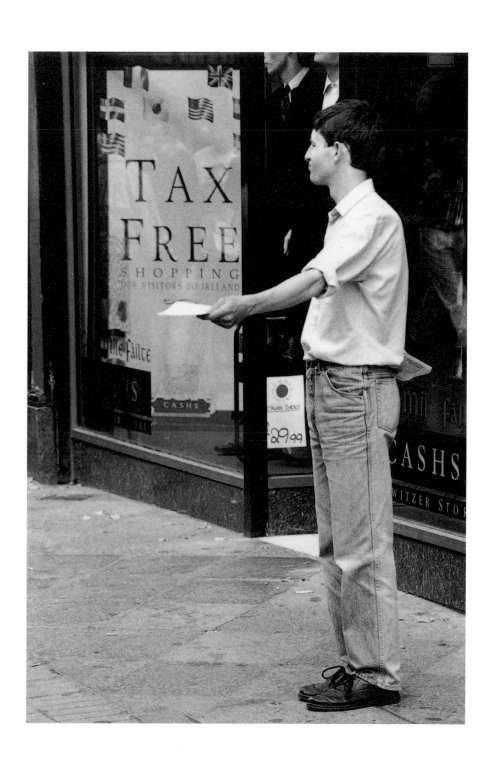

Pavement Art

Street art has become very popular in the city centre. These artists started by drawing on the paving slabs but, of course, that meant they had to start afresh every day. Many have graduated to doing their work on sheets of canvas which they tape onto the footpath and they can work more easily on this. They seem to earn a rather precarious living. The police are not normally listed among their patrons as they tend to cause obstructions on the pavements. Passersby often have an appreciation of their work and make small contributions to the artists.

Facing page: A street artist takes a break.

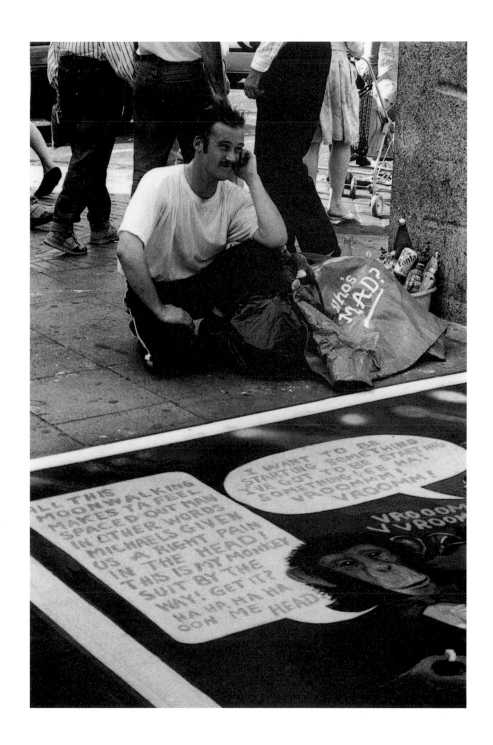

Selling "De Paper"

The Echo Boys are one of the institutions of the city. Traditionally they have dodged in and out of the traffic and pedestrians exhorting people to buy "de paper". There was such a number of them that they had their own club and went on holidays to the seaside.

Some of them have now gone a bit upmarket and have their own stand.

Facing page: A sedentary Echo Boy.

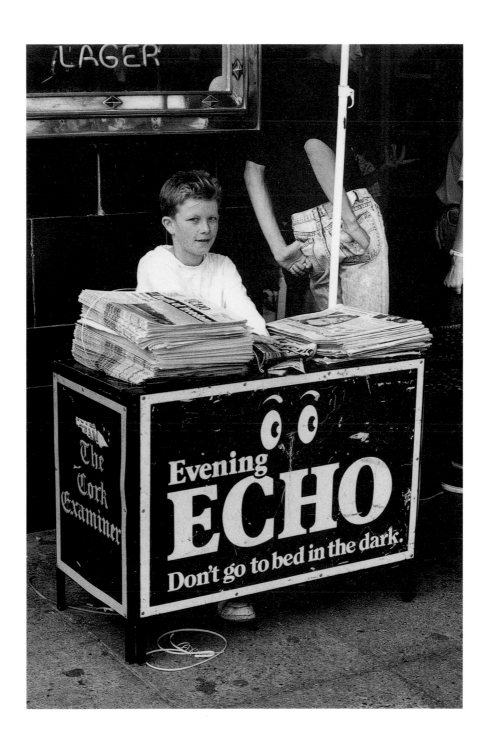

Father Theobald Matthew

In the mythology of Cork this gentleman must surely rank very high. Born in Thomastown County Tipperary in October 1790, he studied for the priesthood at Maynooth. He had to leave rather hurriedly as a result of holding an unauthorised party in his room. He was subsequently ordained as a Capuchin priest in 1813. When he came to Cork he lived at number 10 Cove Street.

He laboured generally for the needy and established a school for underprivileged girls. During the famine years he worked to help the starving. In 1822 he was elected provincial of the order and held this position for 29 years until forced by illness to retire.

During his period in Cork the temperance movement was started by a Quaker, William Martin. Father Matthew became involved in April 1838 and was elected president of the Cork Total Abstinence Society. He preached the temperance message not only in Ireland but in Europe and America.

After his death in 1856 a movement was formed to erect a statue in his honour. This was unveiled in 1882 and it is reported that the crowd exceeded 100,000 people. Excursion trains ran from Limerick and other places and steamers came from surrounding ports. In more recent and perhaps less respectful times it has not been unknown for practical jokers to put a stout bottle in Father Matthew's hand. On occasions he has even been decked in the colours of a local victorious team.

Facing page: The statue in Patrick Street.

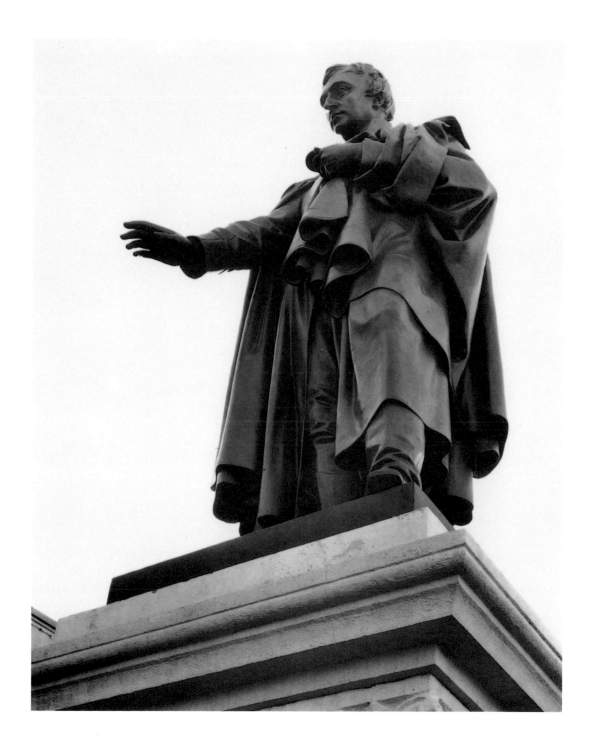

Mangans Clock

Before the development of the new shopping mall a row of shops fronted onto this part of Patrick Street. The most famous of them was Mangans Jewellers which opened its doors for business in 1817. As well as being a jewellery shop they made clocks and installed them all over the country. Their most famous clock was installed in Shandon.

On the street outside the shop was erected a large pedestal clock which was a favourite meeting place for young lovers. The mechanism for this clock was powered by a shaft running through a basement under the street. This shaft was driven by a large weight which hung from the second floor of the shop. When the shopping mall was built the town planners insisted that the old freestanding clock be retained on the pavement.

Facing page: Mangans Clock outside Merchants Quay shopping centre.

Patrick's Bridge

This elegant, triple-arched bridge spans the northern channel of the River Lee at the end of Patrick Street. It is one of the bridges joining the city centre to the north side.

In years past it was common to see shoals of mullet around the bridge but due to pollution they have been missing for some time. At one stage this situation was so bad that a section of a local ballad, referring to the nearby statue of Father Matthew, went
"The smell from the River Lee is wicked,
How does Father Matthew stick it".

The problem is being tackled and fish life is starting to return.

Camden Place on the far side of the river is an attractive row of red-bricked Georgian houses with a rather distinctive bank building at the corner. In the distance can be seen the spire of Shandon which dominates the northern skyline.

Facing page: Patrick's Bridge and Camden Place.

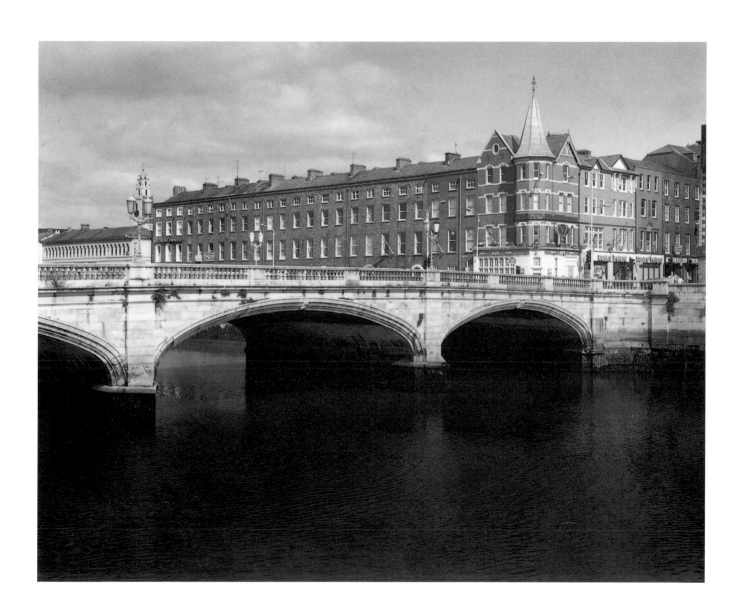

Patrick's Hill

This is the steepest hill in the city. With the popularity of cycle racing as a television spectator sport most people will be familiar with it as the gruelling hill cyclists usually have to climb when they arrive in the city.

Long before cycling became a popular sport this hill achieved a local fame of its own for cycling. Prior to the supermarket era, every decent-sized shop in town had its messenger boy with his heavy-framed delivery bike. For the daring among the messenger-boy fraternity this hill provided a special challenge. They delighted in cycling downhill at speed and the guard on traffic duty at Patrick's Bridge would be left with no option but to hurriedly block all oncoming traffic and allow the hurtling messenger boy through. The idea was to see who could freewheel farthest down Patrick Street and not get caught by the guards. Now that guards have been replaced by unthinking traffic lights a cyclist would have to be very foolhardy before he could even think of such a venture.

Facing page: Patrick's Hill as seen from Bridge Street.

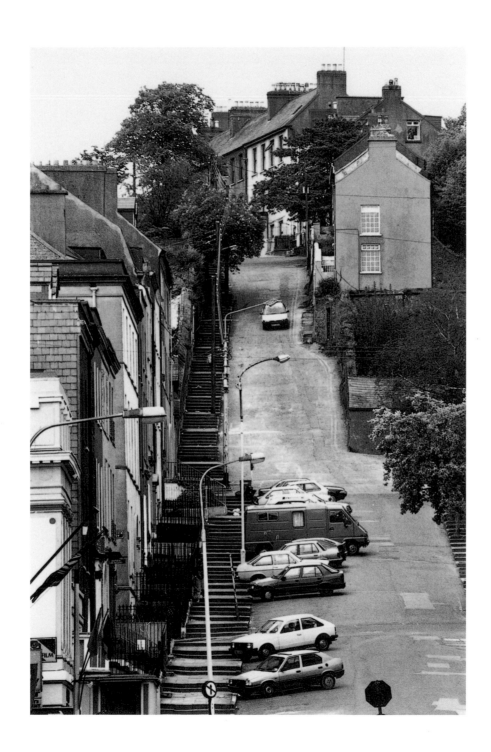

Emmet Place

In the not so distant past the centre of the city must have looked something like Venice. Many of the streets we take for granted today were waterways and what we know as Emmet Place was a U-shaped quay known as Kings Dock. The building which is now the Municipal Art Gallery started life as a custom house to serve the vessels that docked here from all over the world.

The fountain, which the corporation has erected with the distances to various European capitals marked on it, is a reminder of the vessels which called here from all over the world.

Facing page: The Emmet Place fountain.

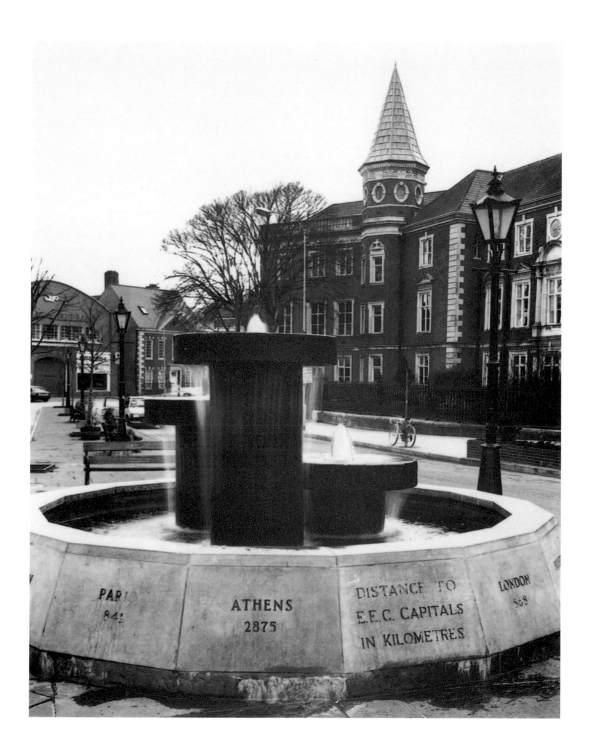

The Crawford Municipal Art Gallery

After the custom house closed, the building was given to the Royal Cork Institution which converted it into a gallery and school of art. This renovation and extension was financed by Mr. Sharman Crawford, of the famous Cork brewing family, in whose honour the gallery in now named.

The gallery has a large collection of both old and new masters and with the help of subscriptions collects important pieces when they come on the market.

Among its collection are some plaster casts which were given by Pope Pius VII to the then prince regent. They subsequently came into the possession of the school of art which was then located in the building. Students such as John Hogan and Daniel Macliese copied them and helped to perfect their art.

Facing page: The Black Panther by Flanencio Cuiran.

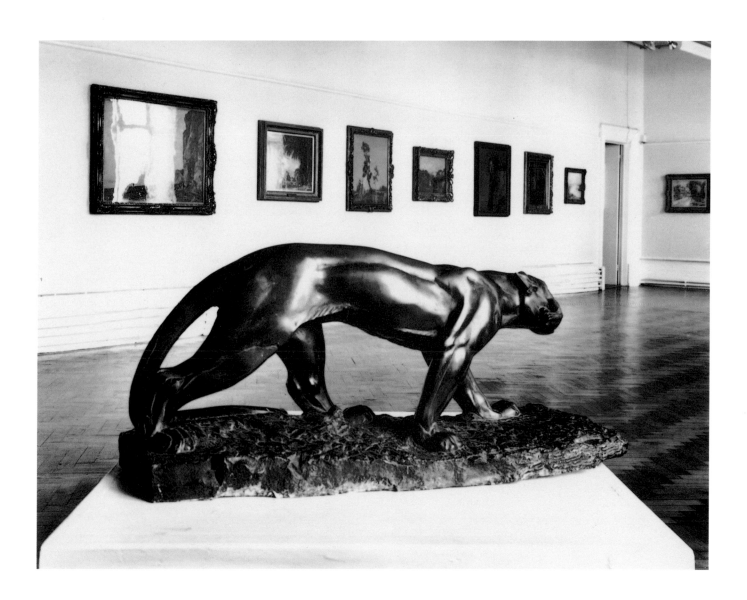

Cork Arts Society

In the city there is great interest in the visual arts. Up to the early 1960's there was only one gallery for visitors and citizens. A small group of people who had an interest in the visual arts felt that there was room and a need for a different gallery. They founded the Cork Arts Society with the aim of creating an awareness of and an appreciation of the visual arts. They opened their gallery at 16, Lavitts Quay where it continues to thrive to this day. Many well known artists owe a debt of gratitude to the society for giving them a start in their career.

Facing page: An exhibition at the Cork Arts Society Gallery.

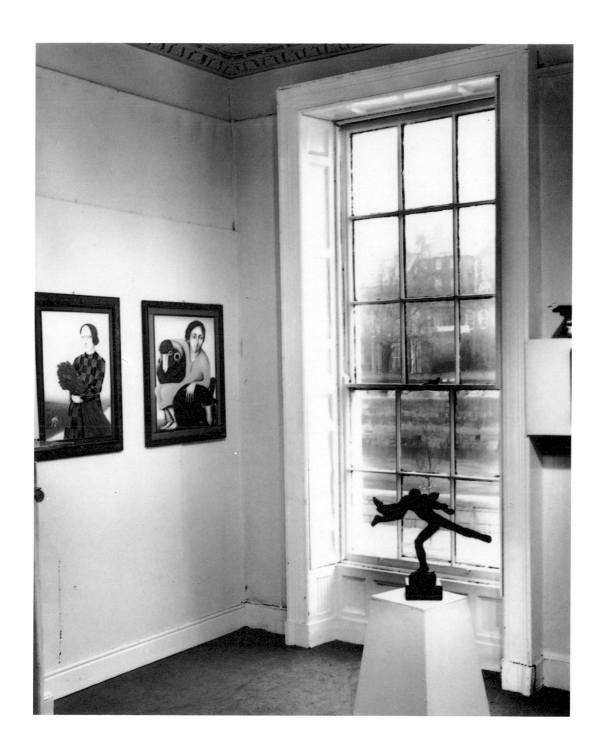

The English Market

The English market is an indoor market which at its peak had 113 different stalls. They sold items such as fish, meat, poultry, vegetables and fruit. In recent years it was extensively renovated following a fire. It is good to see that the old fountain was retained. People assume that this was built just for its decorative affect but it was also for functional reasons. When the market was built in 1610 this was the only source of fresh running water and stallholders requiring water had to fetch it in buckets from the fountain.

A feature of the market which has disappeared are the "Beadles". For over a hundred years they were the markets' own police force and the civic authorities were only allowed in by invitation. The force was disbanded in 1925.

Facing page: The stalls with their brightly coloured awnings lend a continental air.

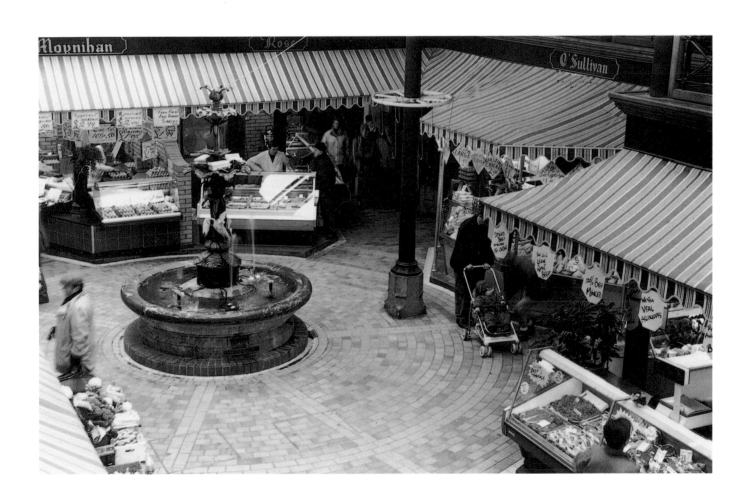

Tripe and Drisheen

A favourite Cork delicacy sold here is tripe and drisheen. Tripe is the lining of the animals' stomach and drisheen is a sausage-like pudding made principally from the blood of animals. Sunday morning was usually the time this particular treat was enjoyed. In recent years this dish hasn't found favour with the younger generation and is becoming rarer.

Butter was one of the staple goods sold in the market. It was none of your modern low-calorie, fancily-packed stuff. The butter came in boxes from outlying dairies and was cut and shaped as required by the housewife. All this was before E.C. regulations or refrigeration and nobody seemed to be any the worse for it.

Facing page: A traditional display of meat products.

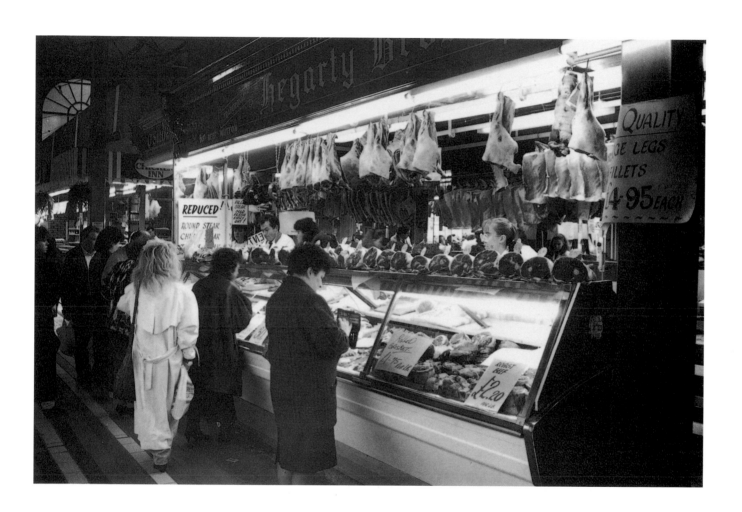

Number 66, South Mall

This beautiful limestone building was opened in 1916 as the headquarters of the Munster and Leinster Bank. Later it became part of the Allied Irish Banks Group.

In his book "Stone Mad", the sculptor, Seamus Murphy R.H.A., mentions that the local stone masons were very upset by finished work being imported from England. This was the cause of a delegation being sent to the bank to protest. Local feelings were assuaged by the rest of the work being done by local men. One interesting by-product of the construction of the building is the very good acoustics and visiting choirs regularly give recitals there.

Facing page: A most imposing facade.

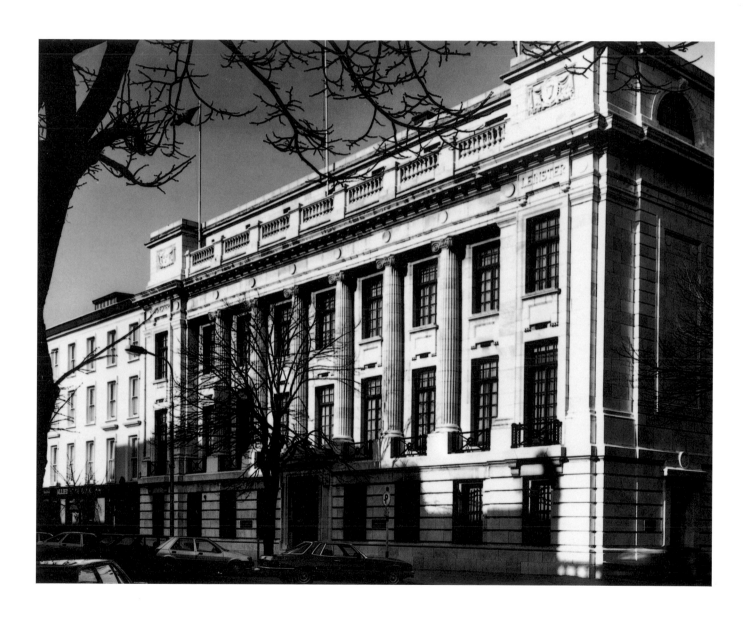

Architectural Styles

This range of buildings is typical of the South Mall. They vary from the tasteless modern through the classical style to the florid Victorian. While they may not sit happily together they do help to illustrate the evolution of the street.

Facing page: The old and the new on the South Mall.

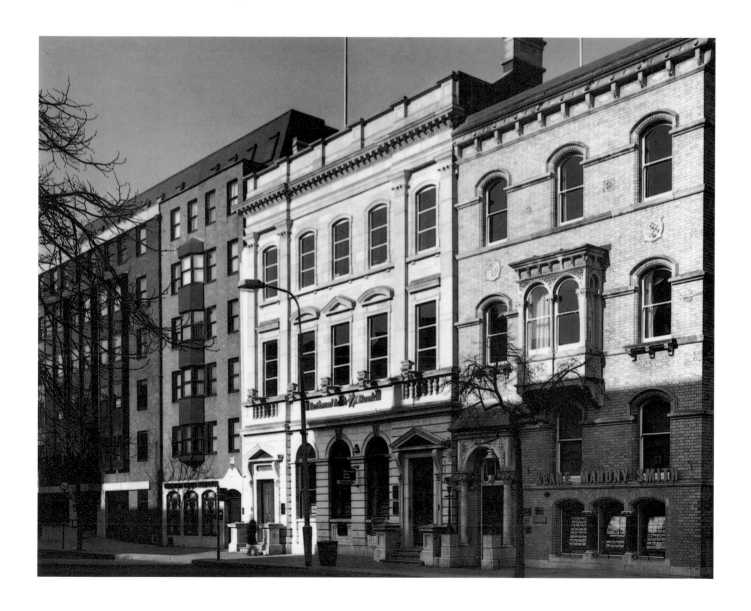

Living on the South Mall

The main domestic buildings on the South Mall have been described as classical Georgian. The fashions of the time dictated that ladies wore wide-hooped skirts and the doors of the houses had to be wide enough to allow them to make a gracious entrance.

The Mall was considered to be the most elegant street in the city and it was popular for "Dandys and their Ladies" to promenade there, especially on Sunday mornings after church.

Facing page: Georgian doorways on the South Mall.

City Cinemas

Today's adults were raised on a diet of "B" movies in the many cinemas once dotted around the city. One of the more popular cinemas was the Assembly Rooms on the South Mall. Like many favourite locations in Cork it had its own nickname - "The Assems". Names of the great cowboys such as Hopalong Cassidy and Roy Rogers, with his equally famous horse, Trigger, were very familiar in that era.

The popularity of cinema declined and the city now has only one cinema complex. The Assembly rooms, which lay idle for some years, have been taken over by the Capuchins. Under their guidance a group of young people are running a cafeteria and delivering light refreshments to the surrounding offices.

Facing page: "The Assems"

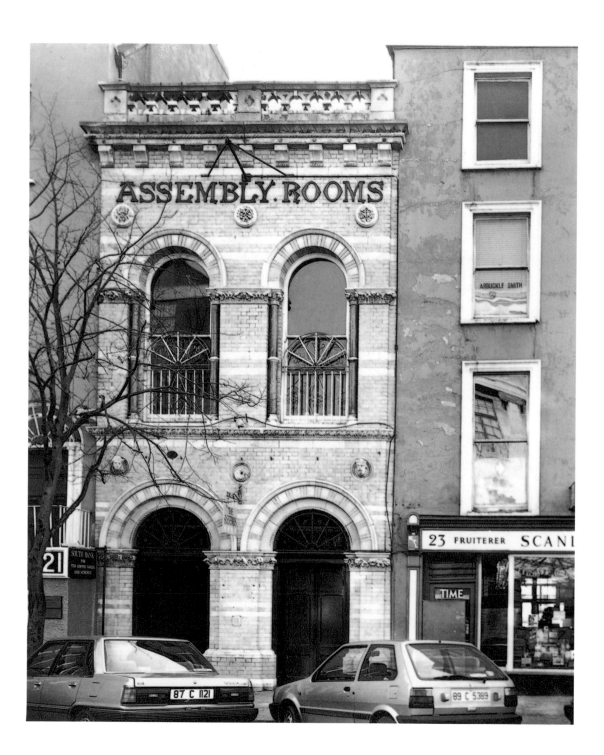

History repeats itself

Before the river flowing down the centre of the street was arched over in the early 1890's, a visitor to the city was struck with the similarity to Amsterdam streets. The houses were mainly those of merchants. Many of them had warehouses in the basement with their entrances at street level or river level. Coffee houses were popular meeting places, where merchants exchanged gossip and did business. It is interesting to see what started out as a warehouse is now a coffee shop.

Facing page: A coffee shop on the South Mall.

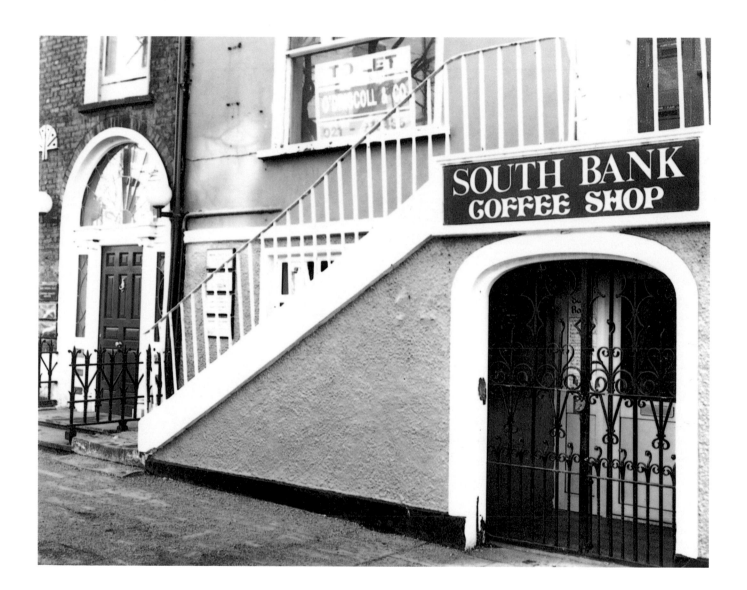

The Banks

These two fine buildings grace the intersection of the South Mall, Lapps Quay and Parnell Place. On the left there is what was the old Provincial Bank, before it became part of the Allied Irish Banks Group. This was the first joint stock bank in these islands and it has been described as having an extravagance of sculptural enrichment. It is highly ornamented and over the windows are carved the coats of arms of many of the centres of commerce in Ireland. At roof level the parapet walls contain carvings of some of the commercial activities in the city.

The other building is the head office of the Cork and Limerick Savings Bank. Presumably it was merely a coincidence that the act setting up the Trustee Savings Banks in Ireland received the Royal Assent on the same day as the act setting up the institutions for the lunatic poor of the country! These banks were set up to encourage thrift and temperance among the smaller savers at a time when many local small banks were failing.

Under its present management the bank has expanded considerably and now has branches in many of the larger towns. This expansion was foreseen at the founding meeting when one of the promoters said that they should be planning to have more than one branch.

Facing page: A view of the banks from the quays.

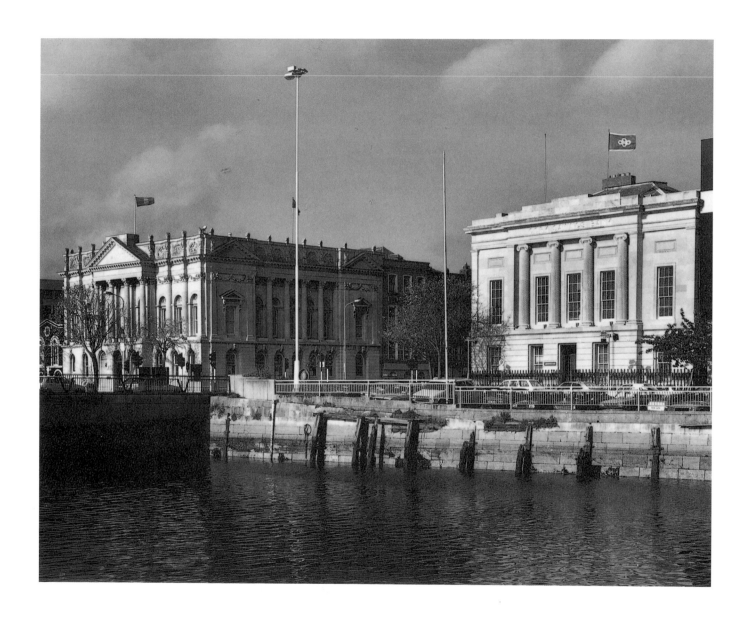

Father Matthew Quay

This Capuchin church and monastery will always in the hearts of Cork people be associated with Father Matthew of temperance fame. It is an ornately designed church whose spire seems out of proportion with the rest of the building. The spire was intended to be taller but finances didn't allow.

Facing page: Holy Trinity Church and Friary.

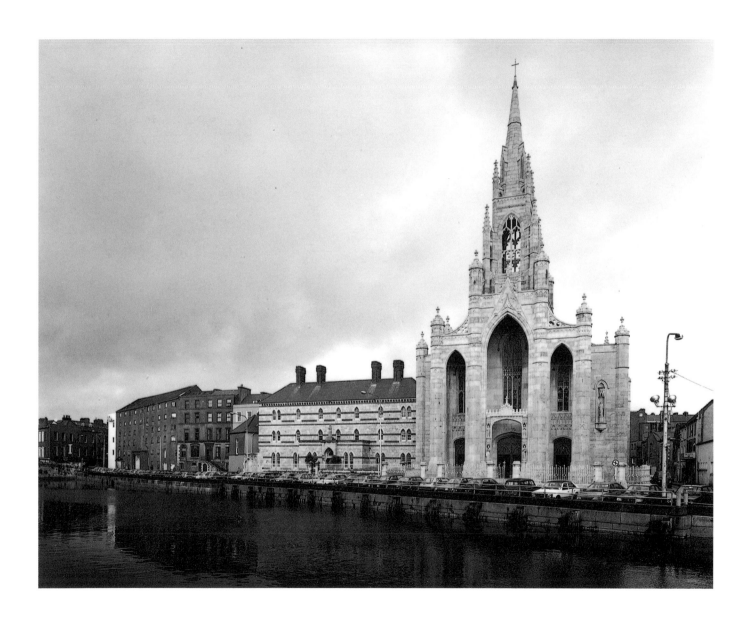

Morrisons Island

The very name of this area brings us back to the fact that the city centre was a group of islands and marshy areas surrounded by arms of the river. This section is bounded by the southern channel of the river and in the evening light the buildings seem to-glow and cast attractive reflections on the water.

Facing page: Moore's Hotel, a well-known feature of Morrison's Island.

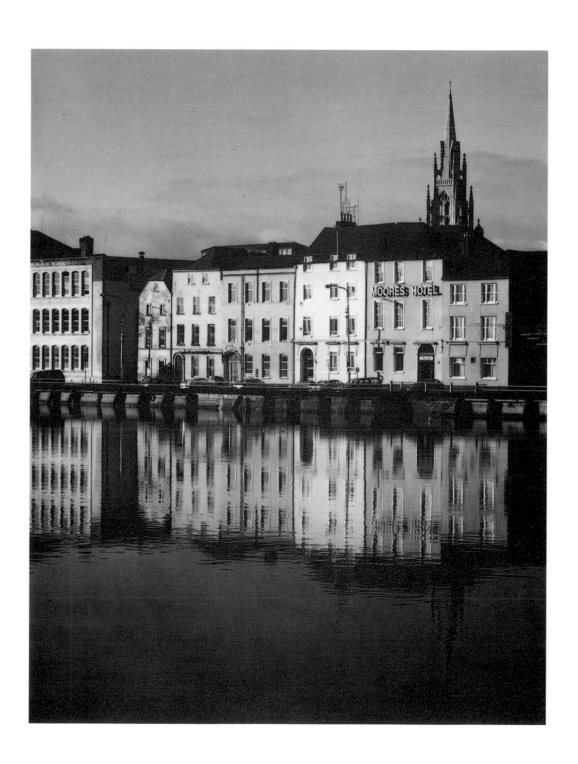

Saint Lukes

Saint Lukes Cross is unique in having the last surviving toll booth in the city. These booths were set up by the corporation when they were given a charter which allowed them to collect tolls on goods entering the city by land. The toll was 1d per head of cattle and a $^1/_2$d on pigs and sheep. These amounts were in pre-decimal currency. The right was extant up to 1967 when it was formally abandoned. To the right of the toll booth is an old horse trough. These water troughs were a regular feature of the city in the days of delivery horses and a few of them still survive.

In the background is the lovely Romanesque church of Saint Lukes. As is so common around the city it is a mixture of red sandstone and white limestone. This mixture was so popular that it was dubbed the "Streaky Bacon" effect.

Facing page: The toll booth and trough at Saint Lukes Cross.

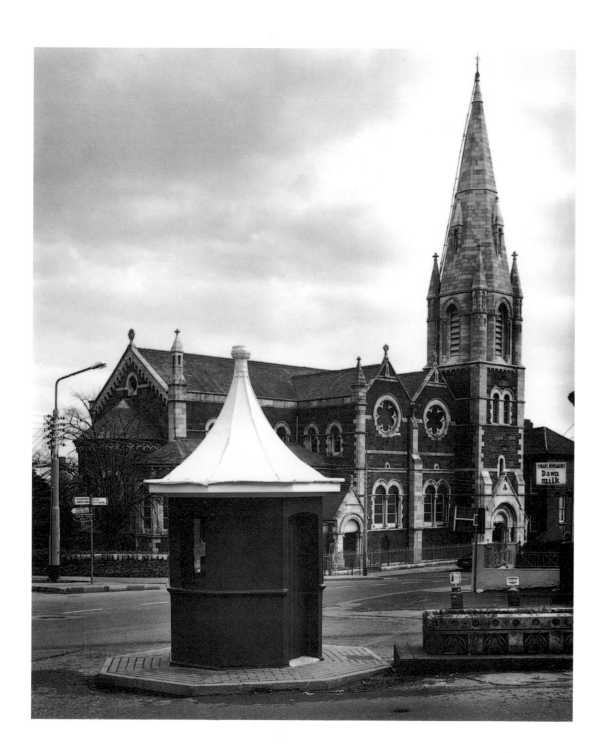

Henchy's Pub

From 1884 until 1991 the Henchy family owned and ran this licensed premises. At one stage they had a general store attached to the pub but this was abandoned to allow them to concentrate all their energies on their world famous pub. The Observer newspaper produced a list of the top 100 pubs in the world and Henchy's featured on the list.

Facing page: Henchy's Pub.

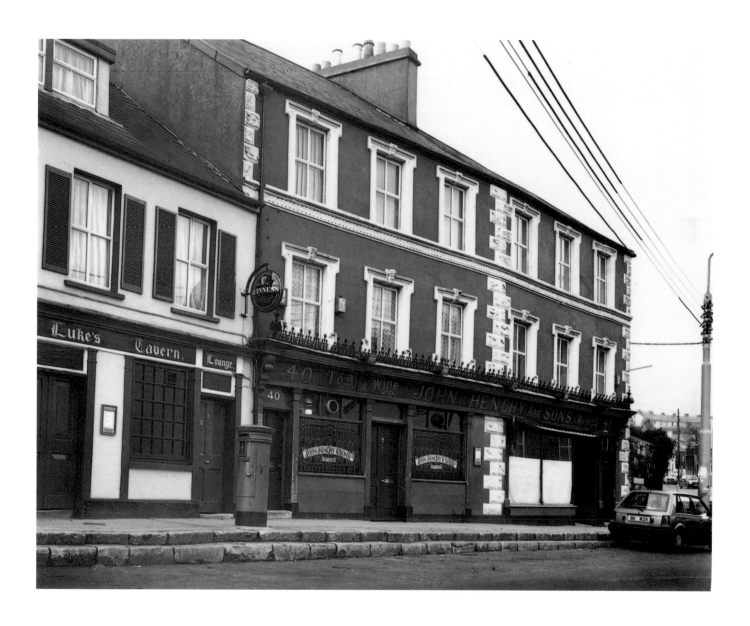

The Rock

Around the city there are numerous little neighbourhoods which time seems to have passed by. One of these is the Rock area between the North Mall and Blarney Street. It is a clutter of little laneways going between, around and eventually above rows of cottages. These were once owned by Lord Cork. The main section of the area is the Rock Terrace. This is a row of old cottages and one of them must surely qualify as being one of the smallest housefronts in the city.

Facing page: Small house on Rock Terrace.

The Rock Steps (1)

Where these steps swing right and head up for Blarney Street there is a naturally occurring shape in the rock which looks like a chair. This is known as "the devil's seat" and was a cause of great fear for children in times past. These more worldly-wise young girls don't seem to be in the least apprehensive. In the background is another type of seat. This is the old seat of learning in the redundant Rock School which houses the local community association.

Facing page: Looking up the Rock Steps.

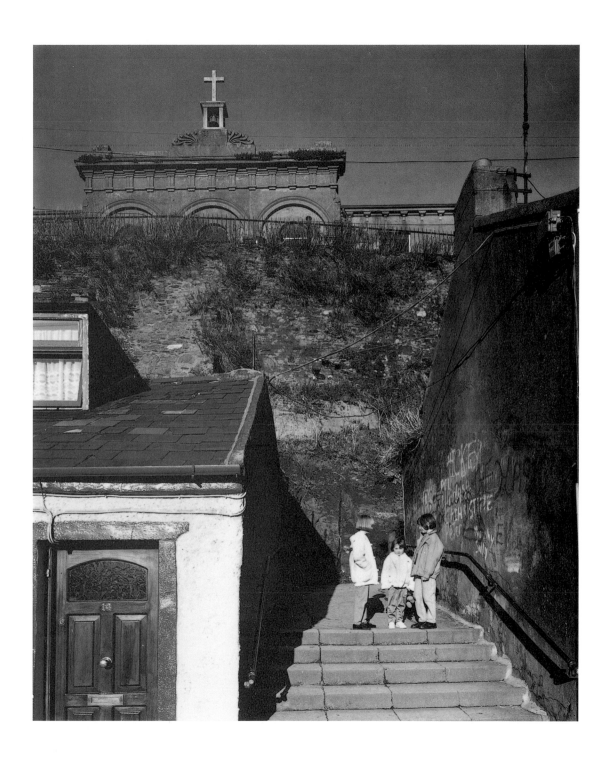

The Rock Steps (2)

Houses here are squeezed into every corner. The terrace provides a middle ground between the lower houses and the lane passing up onto Blarney Street.

Facing page: Cottage-style houses in Rock Terrace.

The Rock Steps (3)

Just before the turn up into Blarney Street a whole vista of rooftops is laid out. The layout is so irregular that it takes some time to understand the maze of houses, lanes and terraces.

Facing page: Overlooking the Rock Terrace and lanes.

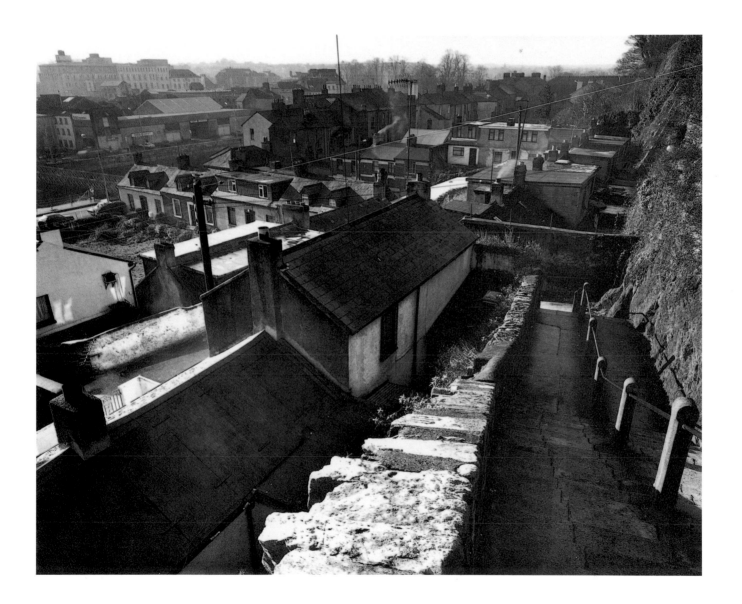

Looking North from Kent Station

A feature of Cork city is that it is built in a valley, the commercial centre is on the valley floor and the residential areas are on the surrounding hills. This is most dramatically seen on the northern side of the river. Hidden under the sign for Paddy Whiskey is the railway track for Dublin. This passes under the hills and emerges on the far side of Blackpool.

Facing page: Tiered terraces overlooking Lower Glanmire Road.

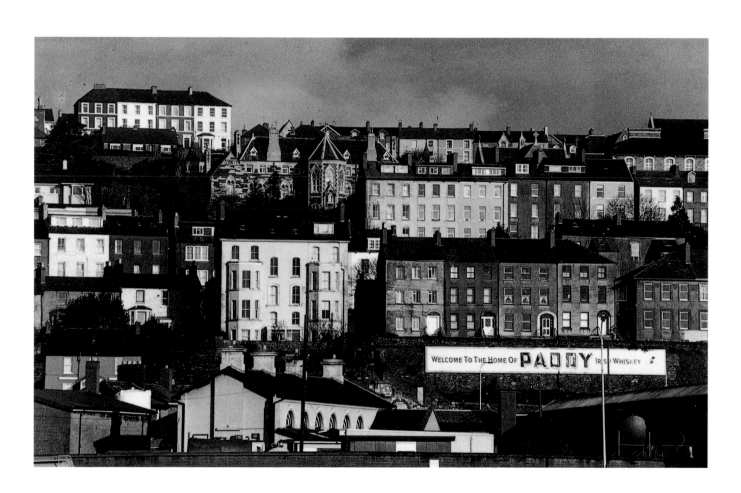

Urban Renewal

When the slums in the city centre were being cleared extensive developments occurred on the north side of the river. Gurranabraher church on the skyline is five hundred feet above the river level. Because of the fact that somebody looking up to the heights from the city centre could only see a collection of roofs the area got the name of "The Red City".

Facing page: Modern housing developments looking north from the Lavitts Quay car park.

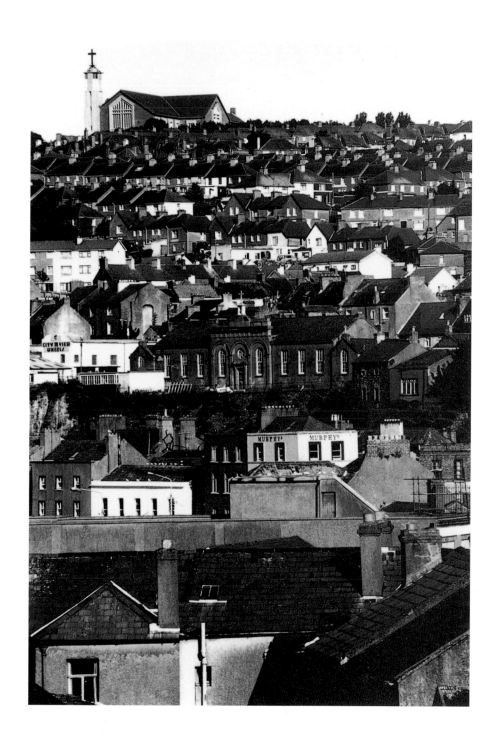

A Trinity of Churches

Looking north across the river from the new multi-storey car park on Lavitts Quay the upper sections of these three churches come together in a rather interesting way. In the foreground is the Dominican church of Saint Mary's on Popes Quay. To the left and behind it is the familiar and much loved pepperpot shape of Shandon. In the distance the tower of the Catholic cathedral rises over the roof tops.

Facing page: Saint Mary's, Shandon and the Cathedral.

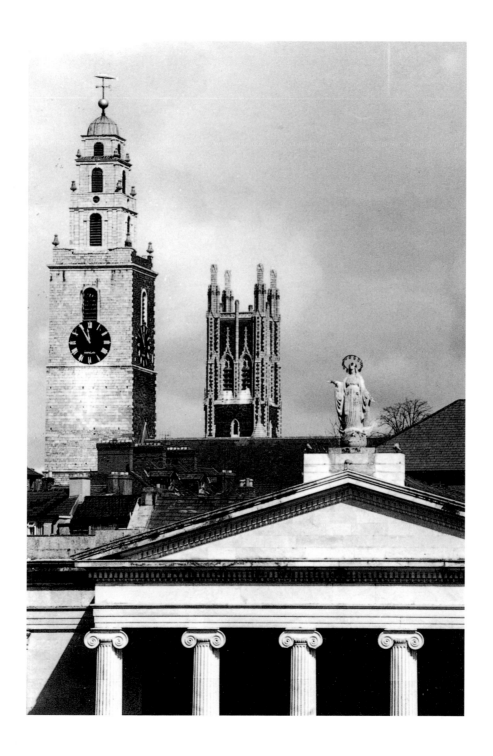

Shandon Street

This area traditionally had a fountain at its junction with Popes Quay. It was removed in the early part of the century. As part of the celebrations in 1985 to mark the eighthundreth anniversary of the granting of the first charter to the city, the corporation erected flower beds and a fountain. These are set out in the shape of "800".

Facing page: Section of the fountain and flower beds.

Church Avenue

The laneways around Shandon and Saint Mary's cathedral contain a world all of their own. There has been a lot of redevelopment in the area but some of the old lanes are still thriving. They are being made a feature by the corporation. In recent times they have repaved this street with a brick paving which is more suitable than the all pervasive concrete or tarmac.

By spending time wandering through these small streets a flavour of the area that was can still be savoured.

Facing page: Evening shadows on the painted brick houses.

Lower Barrack View

In the older parts of the city there are grand imposing church towers and spires. Nearby there always seems to be modest cottage-style dwellings, huddled as if seeking protection.

Facing page: In the shadow of the cathedral.

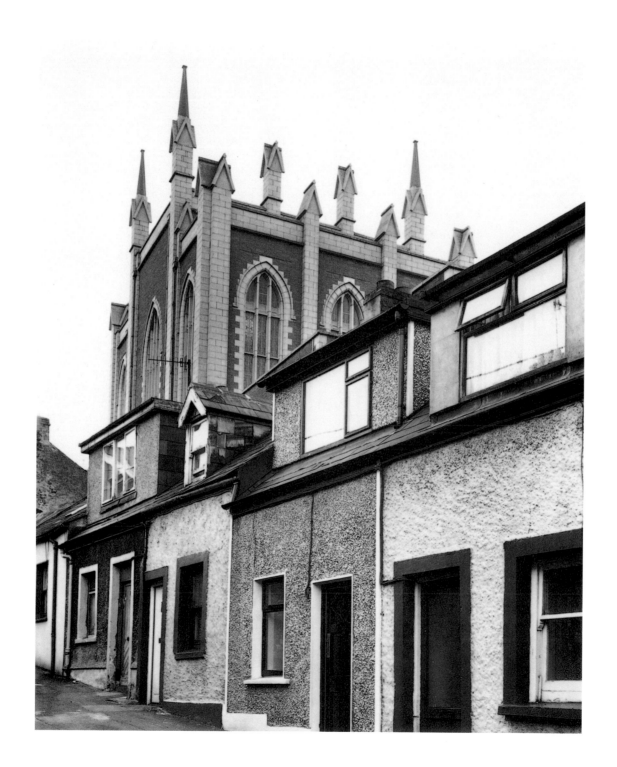

Saint Mary's Cathedral

In terms of ecclesiastical architecture in the city, the Catholic cathedral or the North Chapel, as it is more commonly known, is rather overshadowed by the more imposing Saint Fin Barres and the nearby Shandon.

This cathedral serves a very large area of the north side of the city. It sits on a level site at the top of Shandon Street, a spot where the rising ground seems to pause briefly before tackling the heights of Gurranabraher.

The cathedral is interestingly juxtaposed with the rather more temporal presence of a bookmaker's shop which presumably allows people to hedge their bets.

Facing page: The North Chapel.

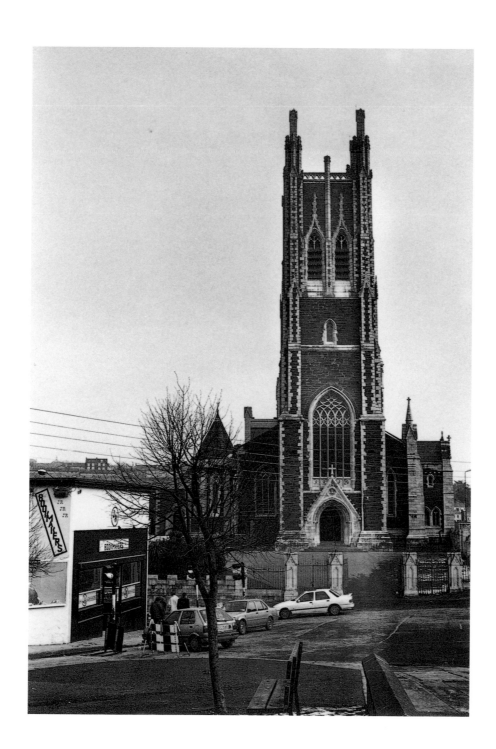

Skiddy's Home

This unique building was nearly lost to the city some years ago when it was decided to demolish it and build a nurses home for the now defunct North Infirmary hospital. Only timely action by a local preservation society saved it and it has been renovated and converted into apartments. It is the oldest inhabited building in the city and part of it dates back to 1620 when Clement Skiddy settled £24.00 on the building for the benefit of twelve aged widows. A subsequent annuity was given by a military man for the support of seven protestant soldiers. Adjacent to the almshouse stood the old Greencoat school. This has been demolished but the two lead figures affectionately known as Bob and Joan were saved and have been moved to Shandon bell-tower.

Facing page: The courtyard of Skiddy's Home.

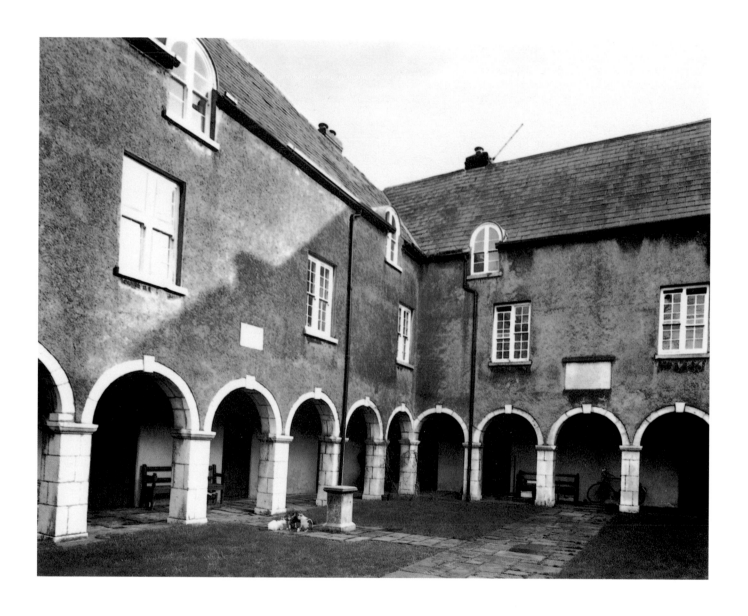

Shandon and the Butter Exchange

The name Shandon comes from "Sean Dún", the Irish for an old fort. The church is over two hundred years old and is of an unusual design with a golden salmon on top to act as a weather-vane. The fact that two different types of stone were used in the construction of the tower has given rise to various stories as to why this should be. One is that two different contractors were engaged to build the tower and that each of them had a different quarry. Therefore two faces are of red sandstone and two of limestone. Another story is that the more genteel limestone faced in towards the city whilst the rougher sandstone faced out into what was at that stage the country.

Each face of the tower has a clock on it. This was the largest four-faced tower clock in Europe until Big Ben in London was developed. For some reason all the faces used to show slightly different times and this earned it the nickname of "the four-faced liar".

The building in the foreground is the remains of the old butter exchange. It started life in 1796 as a butter market and the quality of its produce became so famous that it was at one stage the hub of the butter world. Butter was shipped to places as far away as India. It is said that the explorer Stanley came across a Cork butter firkin during his travels in Africa. The Shandon Craft Centre is now located in the Butter Exchange building.

Facing page: The Butter Exchange and Shandon Steeple.

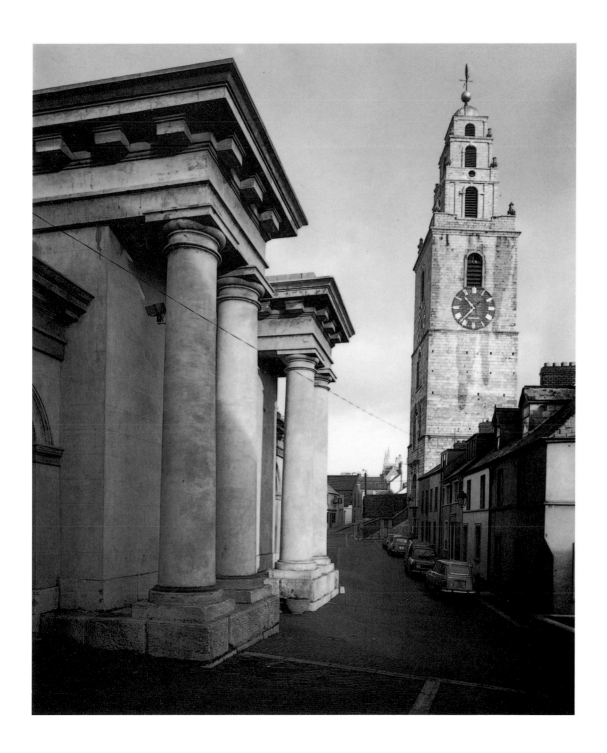

View of the Interior of Shandon Bell-Ringing Chamber

Visitors from all over the world love to come to the bell-ringing chamber in Shandon and play tunes on the bells.There is a row of numbered pullcords and by following the numbers set out on music sheets a variety of popular tunes can be played. We are all familiar with the childhood activity of painting by numbers but music by numbers is pretty unusual!

Perhaps the most famous person associated with Shandon is Father Sylvester O'Mahony, best known by the name Father Prout. He was a catholic priest who relinquished Holy Orders and became a journalist in England. He came back to Ireland and was eventually received back into the catholic faith. His best remembered work was the poem, "The Bells of Shandon",which contains the verse,

"With deep affection and recollection,
I often think of those Shandon Bells,
Whose sound so wild would, in days of childhood Fling
round my cradle their magic spells"

We can only speculate as to how many expatriate Corkonians have recalled these lines while in foreign parts.

Facing page: Visitors to the bell-ringing chamber playing a tune on the bells.

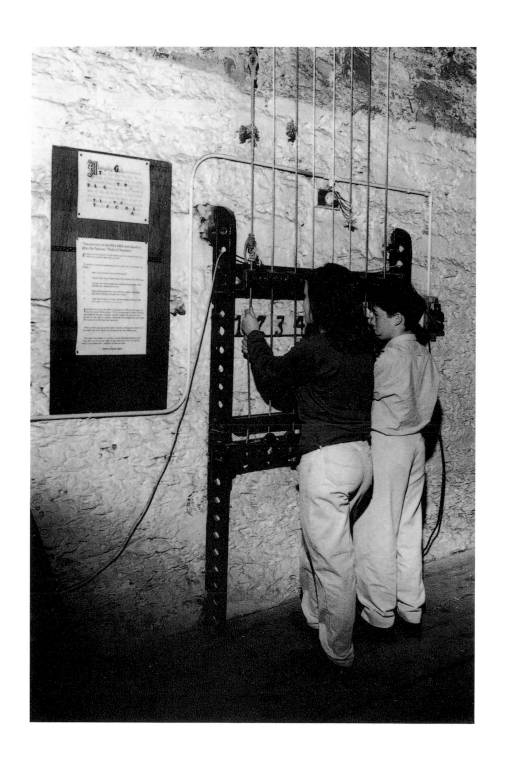

Going Downtown

This young girl seems to be in a hurry to get to town as she skips ahead of the others. The narrow street is typical of many on the northside where the roadway had to be cut with grooves to allow the delivery horses get a grip with their iron horseshoes.

Facing page: Easons Hill

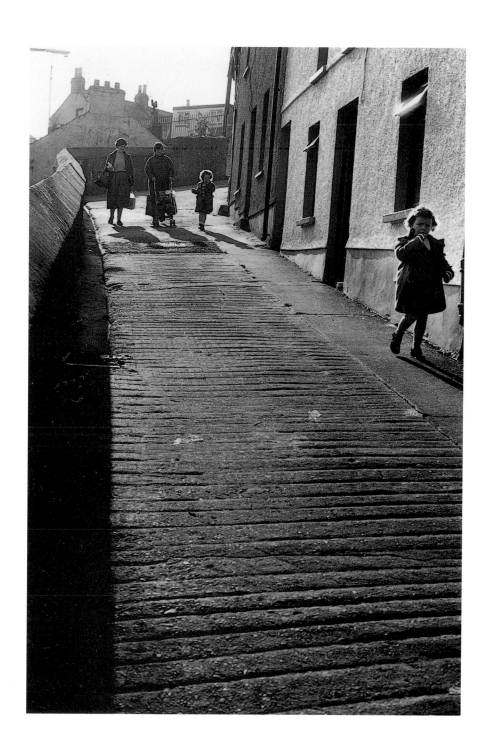

The Fever Hospital Steps

This gentleman walking in the sunshine seems to be a million miles away from the sad history of the area. Off these steps was located the fever hospital which was built in the nineteenth century to help cope with the plagues of thyphoid fever which were sweeping through the city. At one stage ten percent of the population was affected. So bad was the infection that ships from Cork were subjected to quarantine in foreign ports and at home there was a suggestion that communications between Cork and Dublin be severed. Due to the heroic work of a small number of dedicated people, many of whom lost their lives as a result of their endeavours, the plague was overcome and conditions in the city were improved to prevent a recurrence. So successful was the activity of the hospital and the staff that they eventually worked themselves out of a job!

Facing page: Looking up the steps.

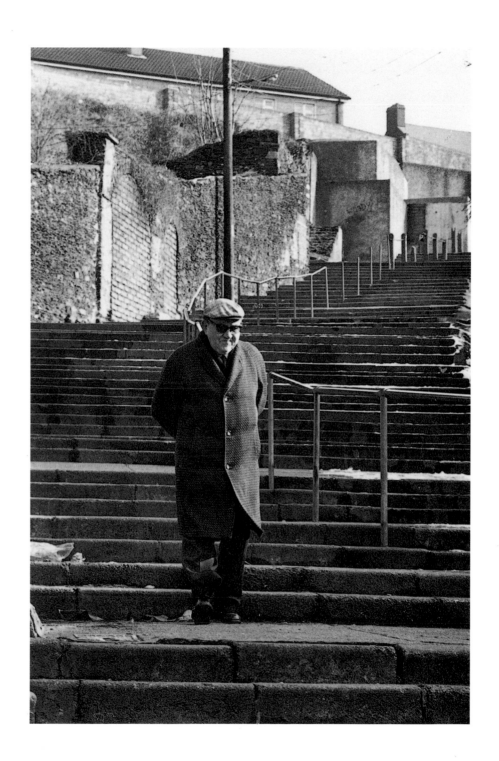

A view of Poweraddy Harbour

Despite the fact that this couple are walking into an area known as Poweraddy Harbour it is unlikely that they are seeking to board a ship. Despite its name all the harbour consists of is a little stream which flows through Blackpool on its way to join the Lee. During the last war one of the sensational English newspapers had an exclusive that the Irish Government was allowing German U-boats to shelter in Poweraddy Harbour.

Facing page: Bringing home the bacon.

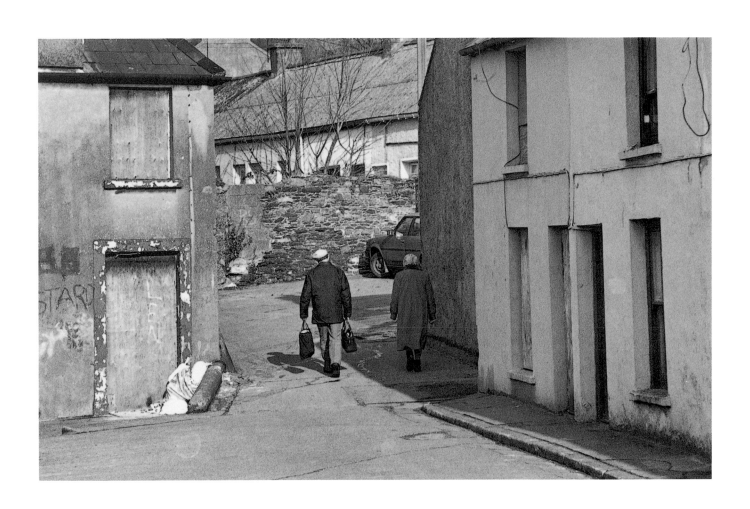

Economic Change

Times are changing in Blackpool and many of the local businesses have failed. The corporation are planning to run a ring road through the area and perhaps this might encourage a general resurgence.

Facing page: Even "Odds and Ends" don't sell.

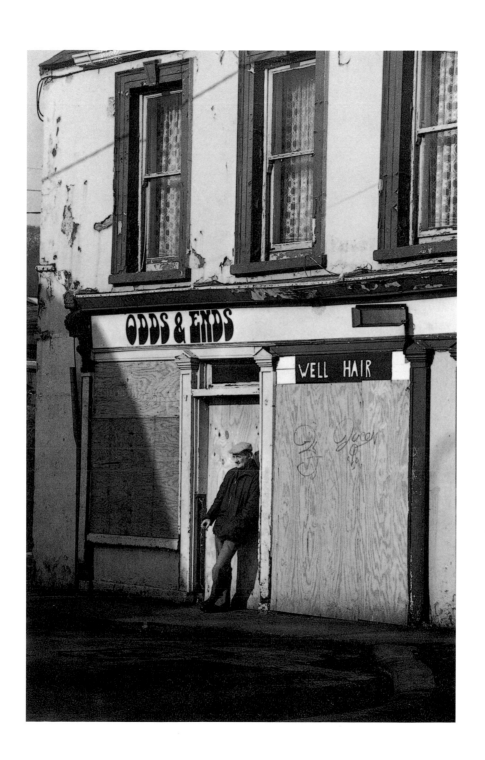

Barry's Place

James Barry, a prodigy artist, was born and reared in this area. At a young age he was made a member of the Royal Academy and appointed their professor of painting. He was regarded as having one of the greatest artistic intellects of his age but because of an irascible temper he was eventually expelled from the Royal Academy. He is one of the very few Corkmen to be buried in Saint Paul's Cathedral in London. His sister was also a most unusual person. Disguised as a man she qualified as a medical doctor and served with distinction in the British Navy, without her true sex ever becoming known. It was only after her death that her secret was uncovered.

Facing page: Plaque erected at Barry's Place, Blackpool.

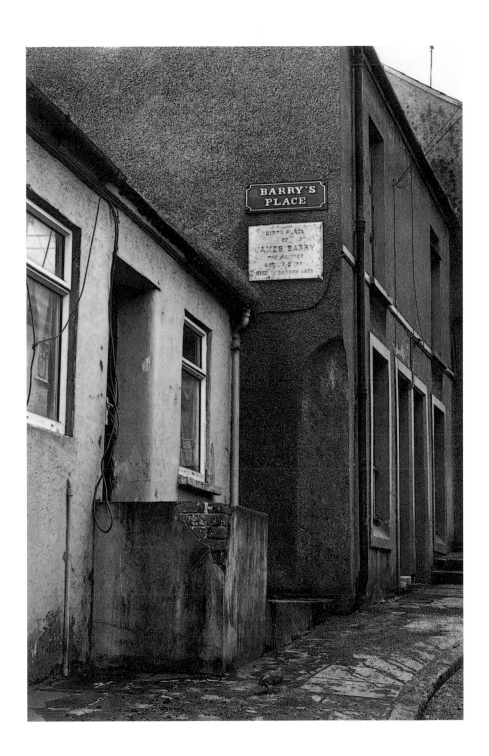

Second-Hand Goods

In other times, when the going got tough, there was always the pawn shop. These no longer seem to be popular but today there seems to be a boom in shops selling second-hand goods. Although this section of the city is not renowned for the quantity of its public toilets this window seems to be carrying the concept of the public toilet a bit too far!

Facing page: A display of second-hand goods.

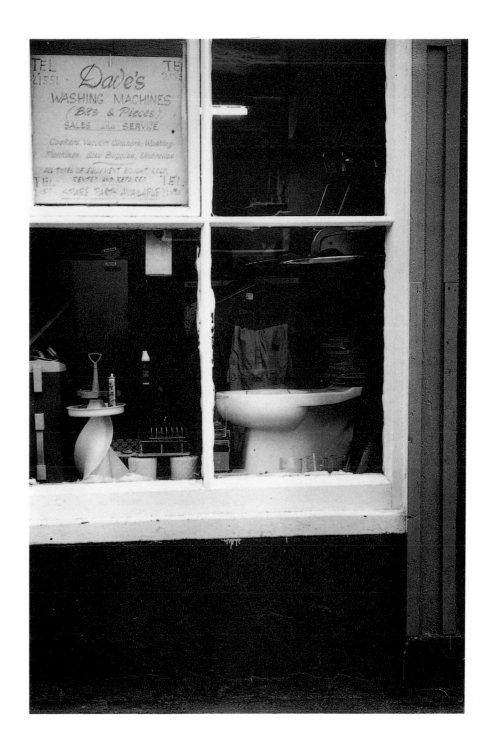

Maddens Buildings

Living conditions were pretty grim for the poorer classes in the old city. These houses,which were built in 1886, were the first to be built under the terms of The Labourers Dwelling Act which was brought in to help alleviate the chronic overcrowding. The patriotically minded organisers of the scheme tried to ensure, where possible, local materials were used. Not every labourer could hope to get one of these houses as two character references had to be produced who would go guarantor for the tenant. A caretaker was appointed and one of his duties was to ensure that no poultry, pigs or pigeons were kept in the houses. The corporation are presently undertaking a scheme to modernise these houses and to equip them with up-to-date facilities.

Facing page: Terraced dwellings dating from 1886.

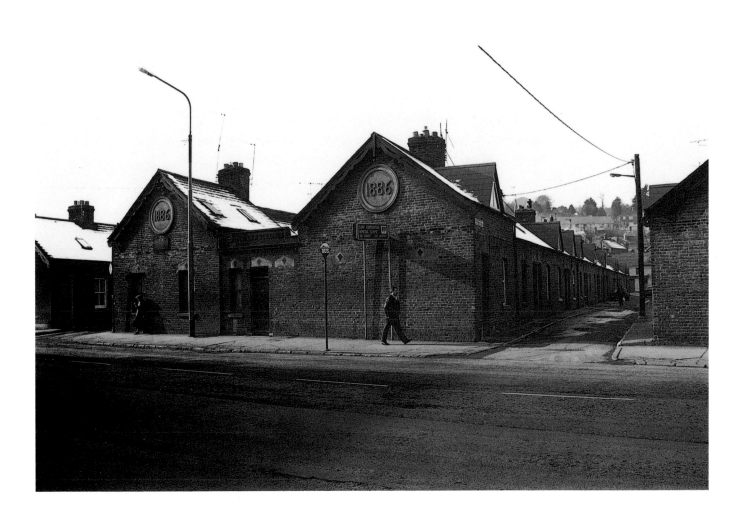

Workers' Cottages

A special feature of the area around Blackpool is the number of little cul-de-sacs running off main roads. These were, in the main, houses of people who worked in local industries such as the tanneries, mills and distilleries which were dotted around the area. They also travelled to work elsewhere. The village of Douglas lies about seven miles from Blackpool and the woollen mills in Douglas drew skilled workers from this area. These workers would have been mainly female who walked the round trip of fourteen miles every day for very small wages.

Facing page: Foley's Row off Watercourse Road.

Ladys Well

Nobody knows for certain how old the tradition of this well is. Certainly it can be traced back several hundred years and perhaps back to early christian Cork. It was originally regarded as a Holy Well and its water was said to have curative properties. When Murphys founded their brewery across the road from it, they named their establishment Ladys Well Brewery. It is still a place of pilgrimage and an annual mass is held there. It is a sign of the times that the statue has to be protected by an iron grill.

Facing page: The grotto at Ladys Well.

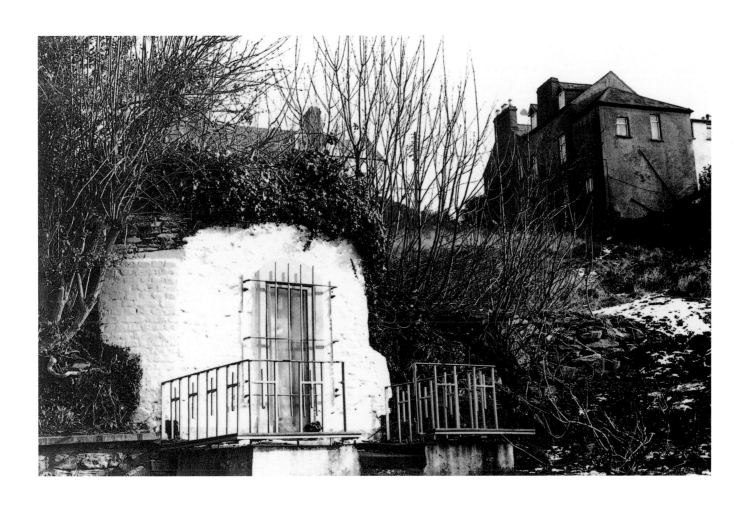

A Community in a City

The old village of Blackpool was one of the many villages which surrounded the city. It is one of the few which has kept a recognisable feel of a separate community. The very fact that a pub would have such a name shows that people here have quite a feeling of community. The young man passing the open door seems to be in a state of indecision.

Facing page: The Village Gate Inn.

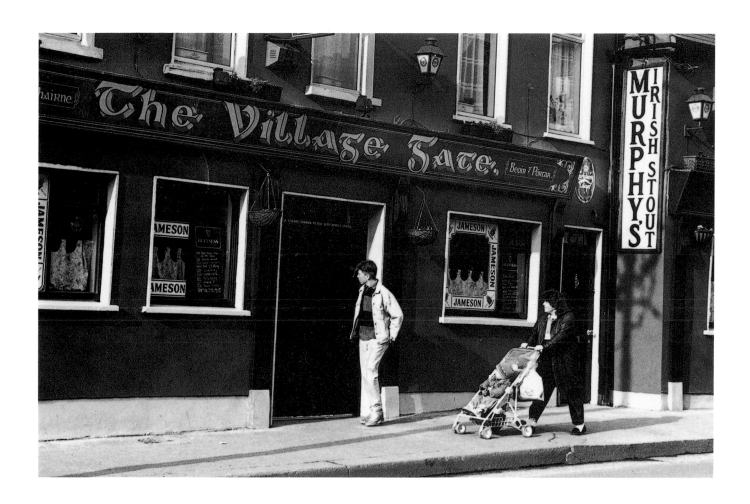